17-2α

'It is easy to forget about painting and just make one of these optical things.' But is Optical art to be dismissed so lightly? Optical (or Op) art grew out of an interest in light, colour and space which has preoccupied Western artists since the Impressionists. Manifestations of Op art are to be found in Futurism, in the Bauhaus, in pre-war geometrical abstraction; contemporary practitioners include Soto, Vasarely and Bridget Riley. By radiation, refraction, juxtaposition, Optical artists have produced colour outside the range of pigment mixture, glowing, radiant colour. By presenting the spectator with objects to be shaped in his perception rather than objects of perception they have created an illusion of form in a new space. Op artists have thus brought the spectator into essential relationship with the work; it is no longer something existing independently of him.

An art form of which even so much can be said surely demands further examination. *Optical Art* is a thorough exploration of contemporary Op art. Cyril Barrett studies its various forms technically and artistically, he describes and explains the general characteristics of Op art and traces its historical development. His account is illustrated with over a hundred examples of Optical art, and he analyses them with exemplary clarity.

Cyril Barrett SJ is Senior Lecturer in Philosophy at the University of Warwick, where he lectures on aesthetics. He also lectures on the history of modern philosophy at the Institute of Theology and Philosophy, Dublin. His previous book on *Op Art* (Studio Vista, 1970) was enthusiastically received as the first detailed and comprehensive study of Optical art.

An Introduction to Optical Art

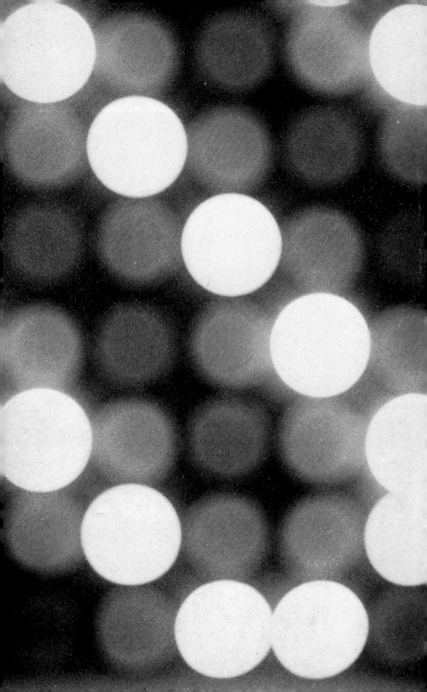

Cyril Barrett

An Introduction to Optical Art

General Editor David Herbert
Studio Vista | Dutton pictureback

Frontispiece
Detail of **François Morellet** *Successive Illumination*
Page 103

Acknowledgements

Pages 24–5, 117, 119, 127 photographs by John Webb, London; page 34 photograph from Musées Nationaux, Paris; page 45 photograph by Bacci, Milan; pages 69, 95, 99 photographs by André Morain, Paris; page 79 photograph by Fotosiegal, Ulm; page 82 photograph by Photos Carlos, Paris; page 92 photograph by Nathan Rabin, New York; page 108 photograph by J. Masson, Paris; page 121 photograph by Cavendish Photographic Co., London; page 125 photograph by M. D. Trace, London; page 131 photograph by Universal Photo Service, London; page 147 photograph by Rudolph Burckhardt.

The author is grateful to the Denise René Gallery, Paris, for permission to reproduce the works of Josef Albers, Getulio Alviani, Antonio Asis, Martha Boto, Toni Costa, Narciso Debourg, Hugo-Rodolfo Demarco, Lily Greenham, François Morellet, Horacio Garcia Rossi, J.-R. Soto, Luis Tomasello, Victor Vasarely, Jean-Pierre Yvaral.

© Cyril Barrett 1971
Designed by Gillian Greenwood
Published in Great Britain by Studio Vista Limited
Blue Star House, Highgate Hill, London N19
and in the United States of America by E. P. Dutton & Co. Inc
201 Park Avenue South, New York, NY 10003
Set in 8D on 11 pt Univers
Made and printed in Great Britain by
Richard Clay (The Chaucer Press) Ltd, Bungay, Suffolk

SBN 289 70137 6 (paperback)
SBN 289 70138 4 (hardback)

Contents

Victor Vasarely *Vega*, 76¾ × 51 in. (193·5 × 128·5 cm), 1956
Denise René Gallery, Paris

Optical art

All art is optical insofar as it is apprehended by the eye. To speak of Optical art is like speaking of audial music. Yet there is a sense in which it is appropriate to refer to certain paintings and what may be loosely called objects, as Optical art. (The term—or to be exact, the more popular abbreviation, Op—was coined by a writer in *Time* magazine in 1964.) A distinctive feature of Optical art is that it relies for its effect on certain physiological processes in the eye and brain which we are not normally aware of either in ordinary vision or in looking at other works of art.

When we look at the world around us we see it divided into fairly well defined elements: houses, roadways, fields, sky, clouds. When we look at a painting we see it as a more or less faithful replica of the familiar world, or as a fantasy world, or as areas of coloured paint. At any rate, it comprises fairly well defined elements. This is our normal mode of perception. But there are times—when we are tired or emerging from an anaesthetic or drunk or when the light is failing—at which the normal processes let us down. Instead of a well defined field of vision we are confronted with confused, unfocused and undifferentiated impressions. We are driving in a car and we cannot tell whether the road before us ends abruptly in a wall or continues with a differently coloured surface. Our perceptual apparatus is momentarily unable to cope, to sort out the impressions it is receiving into a differentiated and ordered visual world. We have suddenly become aware, at a primitive level, of certain optical processes that ordinarily do not come to our attention. Perhaps this is how the world appears to people who have just recovered their sight. It is in this sort of area that Optical art functions.

Optical art makes us aware of some of the processes involved in seeing, or rather it exploits, for artistic purposes, certain perceptual processes. Why artists should concern themselves with such matters I shall try to explain presently. But first a little must be said about these optical phenomena which are the material, so to speak, of the Optical artist's craft.

What happens in an Op painting is, in fact, the reverse of what

9

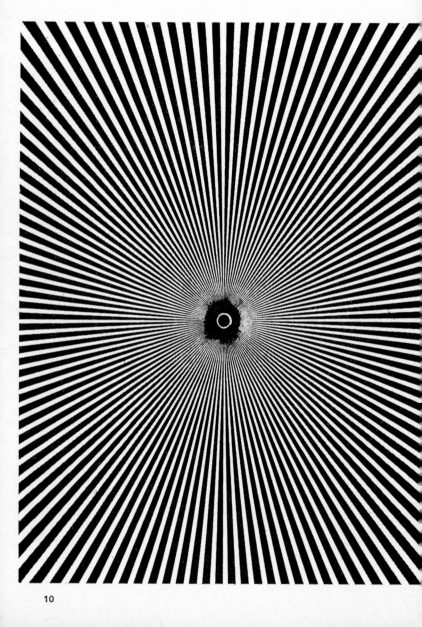

happens when we are momentarily unable to distinguish a road from a wall. In that case, we are first presented with an indistinguishable blur, and later sort it out into road or wall. In an Op painting what at first confronts us is a stable and often rather monotonous repetition of lines, squares or dots. But as we continue to look at this simple structure it begins to dissolve before our eyes. The dots seem to flicker and move; the lines undulate; the surface heaves and billows. Shapes, colours, patterns which were not there before suddenly make their appearance and as quickly disappear. Where the artist uses colour, the colours will alter as one looks at them or will appear in areas where there is in fact no colour (no pigment colour).

The explanation of these phenomena is beyond the scope of this book. There does not, in fact, seem to be any agreed explanation. The inability of the eye to find any focal point, any salient feature or pattern to hold its attention, must certainly play some part. Fatigue, and hence lack of sensitivity to one colour or tone and increased sensitivity to others, also contributes. But these speculations can be left to physiologists and psychologists.

The artist and the scientist are on common ground only insofar as the one explores and exploits these phenomena, and the other isolates and classifies them. It may be helpful, therefore, to begin with some textbook examples in which optical effects appear in their purest, and indeed most spectacular, form, and compare them with works in which the effects are put to artistic uses.

Of all the textbook examples of optical effects there can be few more powerful than the McKay figure. As the eye approaches the centre, the converging lines, becoming thinner and closer, are more difficult to distinguish and finally explode in a blaze of light. At the same time 'shock-waves' seem to detach themselves and radiate outwards from the centre. Finally, faint waves of spectral colour appear across the surface and echo the darker shock-waves. After a while the assault on the eye becomes almost intolerable.

McKay figure

Miroslav Sutej *Bombardment of the Optic Nerve 2*, 88¾ in. (224 cm) diameter, 1963

Compare this with Sutej's aptly named *Bombardment of the Optic Nerve 2*. The assault on the eye is somewhat less than in the McKay figure, but this is not the important difference between them. What counts is the way in which the effect is controlled. In the McKay figure the concentration at the centre and the outward explosion is tremendous, but is quickly dissipated. It is aimless, and if the eye does not soon tire from exhaustion, it will from boredom. But in Sutej's painting the effect is not dissipated or repetitive. There is a lateral movement outwards, as in the McKay figure, but this is counterbalanced by an inward movement; the action is contained within the limits of the picture. There is also movement in depth; the lines, like the petals of some great seaflower, are sucked inwards and then released. It seems to breathe and pulsate with an inner life.

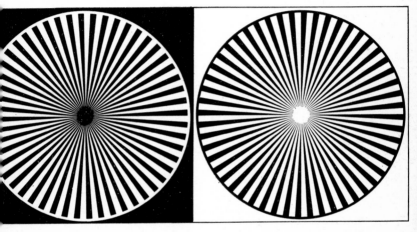

Wolfgang Ludwig *Cinematic Painting*, 24⅛ × 48¾ in. (61 × 122 cm), 1964
Artist's collection

In Ludwig's *Cinematic Painting* the control shows itself in another way. First there is the balanced contrast of the brighter and darker circles, the one drawing the eye towards the centre, the other propelling it outwards. Then there is the definite rhythm of the movement. Finally there is a feeling of stability in spite of optical agitation.

It is much more controlled and less severe on the eye than the McKay figure. The concentric circles appear to rotate with an even rhythm. In place of the 'shock-waves' of the McKay figure, faint radial bands, like propeller blades, gradually make their appearance, moving in a direction contrary to that of the rotating circles. But though these movements are contained within the confines of the figure, they lack subtlety and soon become monotonous. Moreover, the movement is mostly on a plane.

Angel Duarte *C17*, $31\frac{1}{2} \times 31\frac{1}{2}$ in. (80 × 80 cm), 1961
Karl Gerstner, Basel

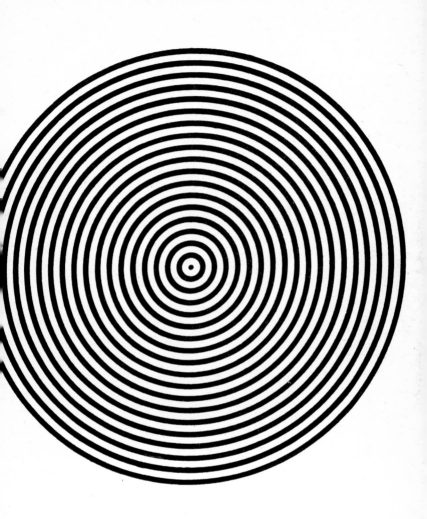

Periodic structure of concentric circles

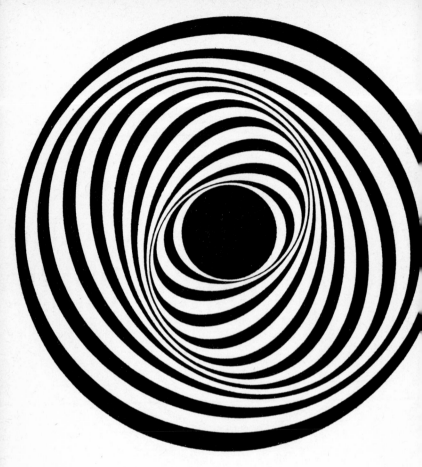

Francis Celentano *Kinetic Painting no. 3*, 48 in. (121 cm), diameter, 1967
Howard Wise Gallery, New York

In comparison, the movement of Celentano's *Kinetic Painting no. 3* is vastly more complex, for it has movement in depth which is further increased if the picture is rotated. But Marina Apollonio's *Dynamic Circular 6S* provides a more interesting contrast. It differs very slightly from Ludwig's *Cinematic Painting*. The circles are not quite concentric; they are somewhat distorted and vary

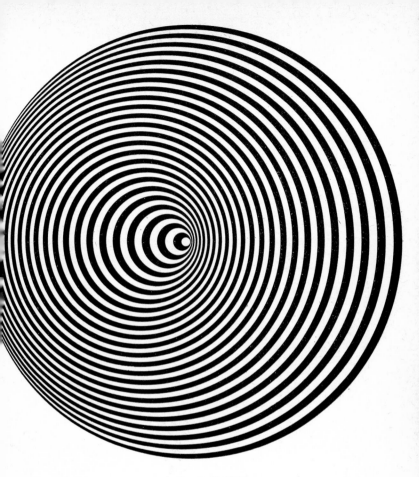

Marina Apollonio *Dynamic Circular 6S*, 1966
Artist's collection

in thickness. Yet the difference in effect is enormous. Not merely is the movement more complex—the faint, propeller-like radial lines bend and twist and reverse direction—but the lines have the unity of an organism, an organism which mysteriously curls in on itself towards some secret recess. And yet, as a structure, it has the apparent simplicity of Ludwig's painting.

Periodic structure of triangles

The illustration above is a structure of repeated elements—here triangles. The optical effects it produces are less obvious and more various than those of the previous figures. The triangles group and regroup themselves in all sorts of ways; the tone of the structure changes continually, one moment bright, another moment grey. Sometimes the triangles seem to lie flat on the surface; at other times they seem to recede, like shadows in a building. But these changes are random and without any coherent pattern. By contrast Bridget Riley's *Straight Curve* which differs

Bridget Riley *Straight Curve*, 28 × 24½ in. (71 × 64 cm), 1963
Private Collection

only to the extent that some of the triangles are smaller or more elongated than others, sets up a definite pattern of change. Although the picture is composed entirely of straight lines, it is swept diagonally by curves. There are also rhythmic movements up and down and across the picture as the triangles grow or diminish in size. The triangles neither lie flat on the surface nor recede in depth, but are kept in perpetual flux, each movement developing out of the previous one in an endless, self-contained procession.

The figure opposite illustrates the optical phenomenon of after-image. If you look at the upper part of the figure, dark grey spots will appear at the points where the white lines cross, and if you look at the lower part, light grey spots will appear where the dark lines cross. These spots are after-images, or, to be precise, negative after-images. A positive after-image is one which is of the same colour or tone as the original image; a negative after-image is of the complementary colour or tone. The complementary of black is white, so a negative after-image of a dark point (in this case, the point of intersection of black lines) will be a bright point or spot. Negative after-images are generally explained as being due to reduced sensitivity. One further thing to note about these after-images is that they do not appear at the point on which the eye is focused; if you try to focus on an after-image in a grid, it will vanish, but another will appear at the point where the eye was last focused. This means that as the eye moves, the after-images appear and disappear and seem to hop about.

After-images play an insignificant part in a work like *Eridan III* by Vasarely, yet they enliven the movement of the picture. In the lower half of the picture they flash on and off like tiny lights and in the upper section appear as dark, stabbing points. But in Bridget Riley's *Fragment no. 6* their presence is much more noticeable. It might be said that they play a dominant role in this picture. It is not until the white after-images, large and small, make their appearance that the picture comes to life. Then a sort of dance takes place, the black circles floating about at a leisurely pace with the white after-images leaping among them.

From what has been said so far it should be clear that an Op painting is like an arena in which visual activity takes place. The Op artist wants something to happen on the canvas. He does not present the spectator with a finished composition but rather with a situation which requires the spectator's reaction for the full development of the work. The American critic, William Seitz, says that these works 'exist less as objects than as generators of perceptual responses'. But, of course, these responses are calculated by the artist (if he knows his job). The Op artist works not only with physical materials—with what is there—but also with what will appear when the spectator responds—with what is not yet

After-image (due to reduced sensitivity)

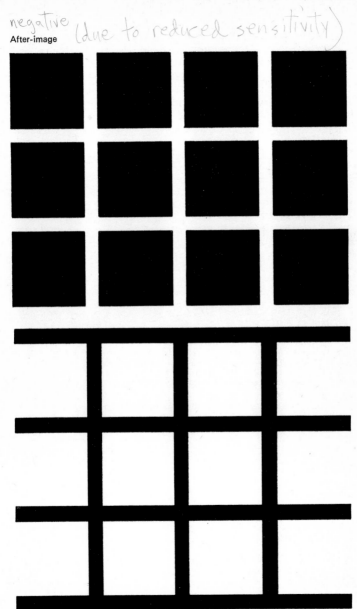

SAINT PETER'S COLLEGE LIBRARY
JERSEY CITY, NEW JERSEY 07306

Bridget Riley *Fragment no. 6*, 29¼ × 29 in. (74 × 73 cm), 1965
Plexiglass print

◀ **Victor Vasarely** *Eridan III*, 76¾ × 51 in. (303 × 201 cm), 1956
Denise René Gallery, Paris

there. When the eye has been properly stimulated, the resulting appearances, the phantom waves and lights and colours, have the delicacy of light itself, of disembodied colour or of some diaphanous substance.

Bridget Riley *Static 3*, $90\frac{1}{2} \times 90\frac{1}{2}$ in.
(229 × 229 cm), 1966
Power Collection, Australia

Op artists have been accused of trickery and legerdemain. As one critic wrote, 'geometrical abstraction has descended into the lower depths of illusionism'. Of course, optical effects are illusory, or perhaps more accurately, hallucinatory. The lines don't really move (don't move physically) nor do the canvases billow ; there are no 'shock-waves', no spectral colours, no bright dots at the crossing of black lines. But Op artists are not out to create illusions, to amaze and bamboozle the public. Or, perhaps some are, but it is not for that their work is valued, if it is valued at all. These effects are produced for their visual qualities, their delicacy, power, luminosity, vivacity ; and if a little amazement creeps in, there is no harm in that. Perspective was amazing when it first appeared, yet Renaissance painters are not dismissed as tricksters on that account. What counts is not the means an artist uses but what use he puts them to.

We have already seen that Op artists use optical effects for specifically artistic ends in creating a controlled, unified and subtle visual experience. But they can also be used as a means of expression.

The Impressionists, in painting a scene, aimed not merely at representing the objects which made up the scene but also at the quality of the sensation that one would experience if one were present. Op artists carry this a stage further. They attempt to reproduce the sensation without the scene. Bridget Riley's *Static 3* is a good, if rather extreme, example. She gives us a description of the origin of the picture (and incidentally of a typical, real-life Op situation) :

I thought of the picture when I was going up a mountain in France which had a vast expanse of shale at the top. It was an extremely hot day. Visually it was total confusion ; I felt that there was no possibility of understanding the space of the situation. You couldn't tell whether the shimmering shale was far or near, flat or round . . . We found it so alarming that we got out of the car, which of course intensified the sensation. But is was much cooler on top and into my mind came the beginning of *Static*, a mass of tiny glittering units like a rain of arrows.

The title refers to static electricity. The 'charge' builds up as one looks at the picture. What initially appeared to be an innocent enough array of regularly placed dots (actually they are ovals pointing in different directions) gradually begins to move, first

Bridget Riley *Pink Landscape*, 40 × 40 in. (158·5 × 158·5 cm), 1958–9
Artist's collection

diagonally in intersecting showers, and then straight towards the
spectator with bright after-images flashing and sparkling. In an
earlier painting, *Pink Landscape,* Bridget Riley tried to convey the
intense heat of the sun on a vast plane, to create the impression
of heat through the way the landscape looked, the shimmering of
a heat haze. In *Static* the approach is direct. She attempts to pro-
duce in the spectator a sensation analogous to that which she ex-
perienced on that shale-covered mountain, to generate an intense
visual response equivalent to the visual response produced by the
burning shale.

Contemporary science exercises a fascination over Vasarely. Two ideas particularly intrigue him: the fact that behind the seeming solidity and stability of things lies intense and complex activity; and, secondly, that the elements of the universe, whether on the macroscopic or the microscopic scale, are basically simple. In one of his writings he says:

At a time when man has extended his knowledge to cover both macro- and micro-cosmos, how can an artist get excited about the same things that made up the day-to-day world of the painter of the past, restricted as it was to what came within his immediate sense-range—his home, the people he knew, his garden . . . Henceforth art will adequately express the cosmic age of atoms and stars.

He sets about his task not by reproducing some example of microscopic or astronomical photography, but by trying to elicit a response similar to that which might be experienced by a scientist actively probing the macro- or micro-cosmos. *Supernovae* is a splendid example of this. Basically it is nothing more than a grid of white lines on a black background. In the upper section of the picture the lines have thinned and thickened to form a dark and a bright area. Below these one row of squares bends inwards to form lozenge shapes. In the lower section circles have been introduced into some of the squares and these become progressively thicker and brighter from right to left. That is all. And yet the optical effects of this structure are such that it pulsates with light against a limitless darkness, concentrating in one great explosion of light and an expanding pool of darkness. The light and darkness, polar opposites, have a further significance for Vasarely. They represent negative and positive elements—matter and anti-matter, electron and proton—which permeate the universe at every level. *Supernovae,* while predominantly referring to macrocosmic events, relates these events to activities in the micro-cosmos. But, leaving this aside, the important thing about this painting is that optical effects are here being used to convey something of the experience of exploring the galaxies, as opposed to recording what a galaxy or cluster of stars may look like at a given instant.

Victor Vasarely *Supernovae*, $95\frac{1}{2}$ × $59\frac{3}{4}$ in. (241 × 150·5 cm), 1959–61
Tate Gallery, London

Somewhat the same result is produced by Morellet's *Four Superimposed Webs*, though there is no evidence that the artist intended the work to have any reference to the stars or to anything else. The structure consists of straight lines, vertical, horizontal and diagonal, yet it appears to be covered with circles. But these are unstable. Sometimes they are single, sometimes in two, three and even four concentric rings. They overlap, merge into one another and disappear for a time. Some have dark, hollow centres, like craters; other centres are bright (formed by the intersection of lines). The whole effect is like that of a cluster of stars, increasing and decreasing in brightness, hard to focus on for any length of time.

Whether Morellet intended this effect or not is immaterial. What matters is that Optical art provides the artist with a means of presenting certain aspects of the universe which is outside the reach of representational art as this is ordinarily understood. Later in the book we shall come across other uses to which optical effects have been put. But it is only fair to mention that a number of artists who employ optical effects in their work repudiate any external reference whatsoever. They wish to keep their work free from associations and connotations. Their concern is with the visual and aesthetic experience provided by the work itself, or with the opportunity it gives the spectator to respond and develop his perceptual powers.

Though optical effects are a distinguishing feature of Optical art, they are not, from the artistic point of view, a defining characteristic. Apart from the fact that optical effects are produced by textbook illustrations which have no claim to be works of art, quite a number of works of art produce optical effects and are not on that account regarded as Optical: works by Poons, Ellsworth Kelly, Stella, for example. What seems to distinguish Op artists from these others is their attitude to the elements of a picture, and in particular to the picture surface. The elements in a work of Optical art, whether they be squares, lines, wire rods or neon tubes, are relatively unimportant. They have been described as 'anonymous'. It is their very anonymity which produces the optical effect. The Optical artist is not primarily concerned with the relationship between elements: he does not build up a composition

François Morellet *Four Superimposed Webs,* $55\frac{1}{8} \times 55\frac{1}{8}$ in. (140 × 140 cm)
1959
Artist's collection

of which they are the stable components. If he did that it would be a very uninteresting composition indeed; little better than a chequered tablecloth. What he is interested in is the changing relations which occur between the elements and the ephemeral images they produce.

This is connected with his attitude to the picture surface. An artist who is primarily interested in the elements of his picture may allow a little movement between them but he must maintain a reference to the picture plane : the more important the elements the more stable they must remain. But where relationship between the elements is not important, there is no need for them to be related to the picture surface ; it may heave and buckle and totally disintegrate. Like the shale on the mountain, the precise location of the picture surface may be impossible to locate. As Jeffrey Steele said of the works of Soto : you can bump your nose against them trying to locate them physically in space. This, more than anything else, distinguishes a work of Optical art from any other work which may happen to produce optical effects.

Detail of **Soto** *Cube of Ambiguous Space*
page 72

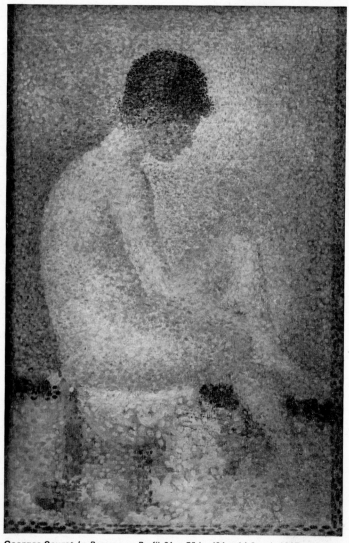

Georges Seurat *La Poseuse en Profil,* $9\frac{1}{2} \times 5\frac{7}{8}$ in. (24 × 14·8 cm), 1887
Jeu de Paume, Paris

The origins of the Optical art movement

What might be called the Op art movement began in the late 1950s and early 1960s. It started mainly as a reaction to the then prevalent informal art: Abstract Expressionism, Tachism, Action painting; paint dripped, sloshed and hurled on to canvas. Younger artists wanted precision. Optical art as then practised by Vaserely offered not only precision but also a new kind of art. Before the war the De Stijl group, which included Mondrian, and the Constructivists had been as precise as one could wish. But the new generation did not want a return to pre-war geometrical abstraction. They wanted something precise and new.

Optical art was not just new. It responded to another requirement which seemed important to the new generation: it made a direct appeal to the spectator; it involved him; called for his participation in the creation of the work. As we have seen, a substantial part of an Optical work is the product of the spectator's physiological responses.

These ideas are embodied in the manifestos of the New Tendency—the name given in the early sixties to exhibitions in Zagreb and Paris—and in particular in those of the most articulate of its members, the Groupe de Recherche d'Art Visuel. Michel Fauré wrote in the catalogue of the New Tendency exhibition in Paris in 1964:

Members of the 'New Tendency' claim to go beyond the ideas both of informal and constructivist art . . . They realize that lyrical abstraction and geometrical abstraction cancel each other out, because, beyond the principles which restrict them, other, newer values intervene: movement, light and monumental space.

In the same catalogue Karl Gerstner wrote:

Our aim is to make you a partner . . . Our art depends on your active participation.

And the Groupe de Recherche (in their manifesto, 'Enough of Mystification') :

There must be no more productions exclusively for:
the cultivated eye,
the sensitive eye,
the intellectual eye,
the aesthetic eye,
the dilettante eye.
THE HUMAN EYE is our point of departure.

Thus the Optical art movement was part of a wider artistic movement with sociological and artistic implications. It was in a sense proletarian. It required no previous knowledge of classical, Biblical or Christian iconography. There were no historical or literary allusions. Moreover, since the final product, the 'work', depended so much on the spectator, with eyes like everyone else's, the artist could no longer claim the usual recognition accorded him and his unique masterpiece by bourgeois society. As someone who has organized exhibitions of optical–kinetic art in various places, I can vouch for the truth of this claim. Wherever these exhibitions have gone they have drawn spectators far in excess of anything that the gallery had previously known.

But, if the Optical art movement began in the late fifties, Optical art itself appeared much earlier. One finds it in Muslim ceramics in Spain, in inlaid marble floors of the seventeenth and eighteenth centuries, in parlour games of the nineteenth century. The Neo-Impressionists almost reached a form of Optical art. If you isolate certain areas of the works of Seurat or Signac they look like Optical paintings. The reason for this is that the Neo-Impressionists were striving for the vibrancy of colour which comes from juxtaposing small areas of contrasting colours. But they had no wish to disrupt the whole picture by allowing these optical effects to play the dominant role which they play in Op paintings. Optical effects were subordinated to representation.

Optical effects, partly obtained by Neo-Impressionist techniques, were used by the Futurists to give an impression of movement. In Balla's picture the figure of the girl running along the balcony almost completely disintegrates. Balla painted this picture after he had been experimenting with abstract colour contrasts and producing what he called 'Iridescent Compenetrations'. But he

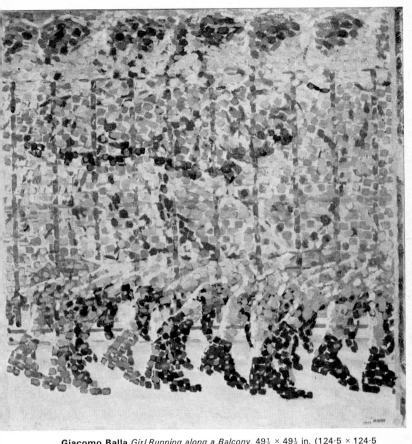

Giacomo Balla *Girl Running along a Balcony,* $49\frac{1}{4} \times 49\frac{1}{4}$ in. (124·5 × 124·5 cm), 1912
Gallery of Modern Art, Milan, Grassi Collection

never regarded these as anything more than experiments. He used them to decorate letters to his family, the walls of a bedroom and a concert hall in Germany, but he never thought of them as works of art in their own right.

In the 1920s three artists, Berlewi, Gabo and Duchamp,

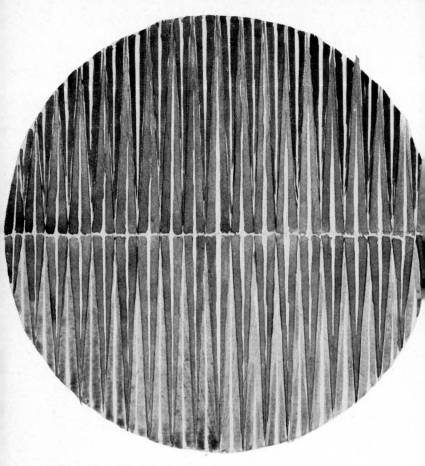

Giacomo Balla *Iridescent Compenetration no. 2*, 30⅜ × 30⅜ in. (76 × 76 cm), 1912
Private Collection

produced works which can properly be called Optical. Although Berlewi claims that his pictures do not exercise on us a direct optical impression and that they are true to the two-dimensional principle of the picture, the optical effect of *Elements of Mechano-Facture* are almost as powerful as those of a Vasarely. Perhaps it

Henryk Berlewi *Elements of Mechano-Facture,* 21⅝ × 21¼ in. (54·9 × 53·7 cm), 1923

would be more correct to say that there is a tension between the strong optical effect in the centre of the picture and the more stable surrounding area. Instead of the whole picture performing optically, the optical activity takes place on a black and white plane or arena.

Gabo's *Kinetic Sculpture* is optical to the extent that the translucent form which a rapidly vibrating rod assumes is produced optically, that is, by the inability of the eye to follow the rod through each phase of its motion.

Duchamp's *Bicycle Wheel* of 1913 might be said to be optical (when rotated) for the same reason. It was a pleasant gadget, he says; 'pleasant for the movement it gave'. In 1920 he made what he called his *Rotary Glass*. This consisted of five glass 'propeller blades', with black and white lines painted at the tips. When they rotated, they appeared as slightly conical concentric circles. This was followed by a revolving glass hemisphere with lines drawn on it. As it moved the lines spiralled inwards and outwards. A similar effect was produced by a series of what he called 'Rotoreliefs', made in the 1930s. These were painted discs which performed to best advantage on a gramophone turntable at thirty-three revolutions per minute. But some of them, as our illustration shows, behave optically even when static. By far his most spectacular optical work, *Fluttering Hearts*, was made in 1936. It consisted of four concentric hearts, alternately red and blue, which, by virtue of the colour contrast, pulsate with increasing velocity as one stares at them. Alas, the effect is completely lost in a black and white illustration.

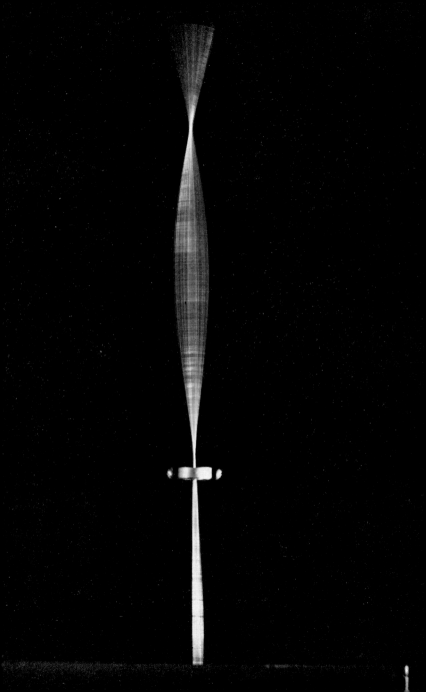

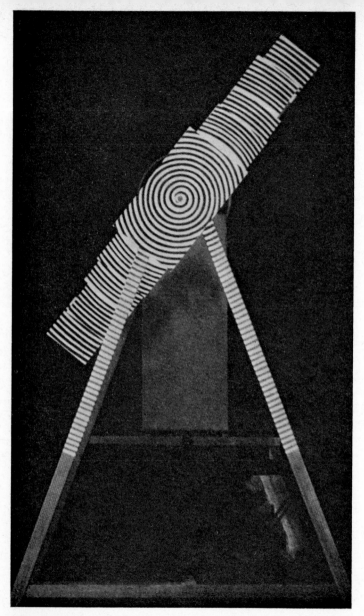

Marcel Duchamp *Rotary Glass*, 1920, reconstruction 1961
Painted glass
Private Collection

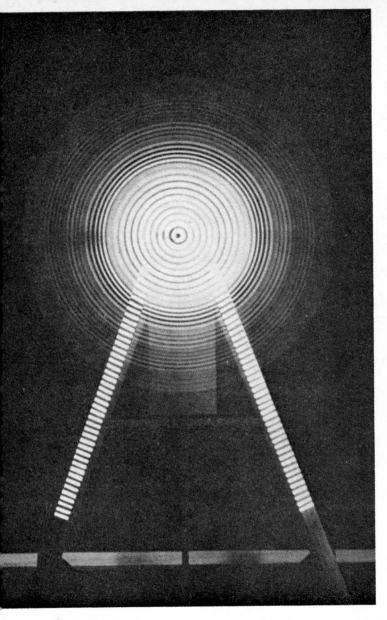

Rotary Glass in motion

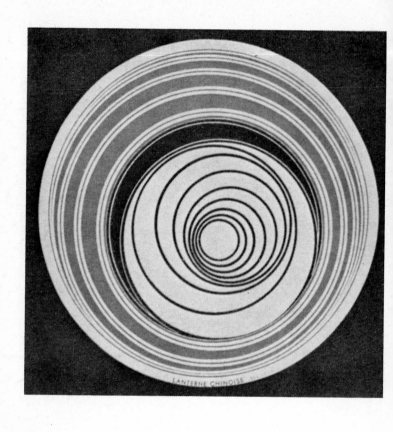

Marcel Duchamp *Rotoreliefs: Lanterne Chinoise*, 7⅞ in. (20 cm), diameter, 1935
Museum of Modern Art, New York

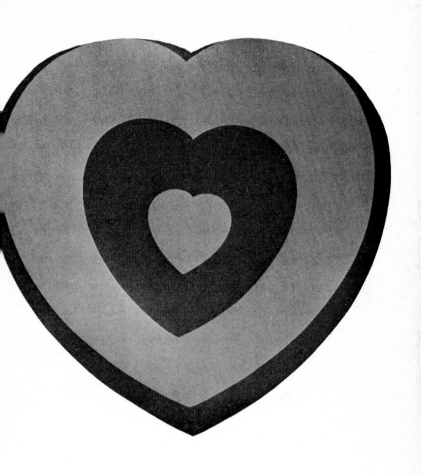

Marcel Duchamp *Fluttering Hearts*, 13 × 20 in. (33 × 50·8 cm), 1961
Schwarz Gallery, Milan

Bauhaus experiment *Black and White Stripes Cut into Concentric Stripes and Displaced, c.* 1928–33

Duchamp's interest in optical effects was, though genuine enough, somewhat wilful; he liked to tease the public. But there were other, more serious investigations into optical phenomena being conducted in the late twenties and early thirties at the Bauhaus, particularly under Josef Albers. These classes conducted by Albers in Dessau and later at Black Mountain College, North

Piet Mondrian *Composition of Lines*, 42½ × 42½ in. (107·5 × 107·5 cm), 1917
Kröller-Müller Museum, Otterlo

Carolina, and at Yale were to have considerable influence on the
development of the Op art movement.

One other artist deserves mention. Though not himself an Op
artist, Mondrian came close to producing Optical paintings in the
last years of his life. His 'New York City' and 'Boogie-Woogie'
series comprised grids of lines broken up into blocks of primary

colours. They flicker like the lights of a great city, which is presumably what Mondrian wanted them to do. Whether Mondrian would have carried them a stage further until they had become fully Optical, no one will ever know, but at least they had a profound effect on later Optical painters. Soto writes of these late works of Mondrian:

Mondrian's last works—*The Victory Boogie Woogie*—those lights! There one sees the beginning of vibration in painting . . . It seemed to me that he had made a sudden leap in the direction of purely dynamic painting realized through optical means . . . that he was about to make the image move optically.

By the 1940s there had thus been a number of isolated instances of Optical art, but nothing that could be described as a movement. Optical effects were regarded either as amusing visual phenomena or as a useful field of investigation for an artist learning his trade. It was not until the early 1950s when Vasarely and Soto started to explore them as an artistic medium that an Optical art movement could be said to have begun.

Piet Mondrian *Broadway Boogie Woogie*, 50 × 50 in. (126·5 × 126·5 cm), 1942–3
Museum of Modern Art, New York

Victor Vasarely *Drawing for Fabrics,* 1932
Artist's Collection

Vasarely and Soto

Two things were important in Vasarely's development as an Optical artist. As a child he had been fascinated by grids, superimpositions and transparencies. On one occasion he drew a 'sun-face' on both panes of a double window and was intrigued by the doubled grimaces as he walked in front of them. Thus the germ of the idea of superimposed transparencies was first implanted in his mind. On another occasion, while in bed with an injured arm, he began to play with the fibres of the gauze dressing and was struck by the way the pattern of interlaced threads changed at the slightest touch. So began his preoccupation with grids. At school he was again fascinated by the grids of isobar maps and the isochronous and isochromatic grids of physics; he filled whole notebooks with grids.

The second formative influence was the course he attended in 1928–9 at Bortnyik's 'Bauhaus' in Budapest. Bortnyik had been to the Dessau Bauhaus and offered to pass on what he learned there to anyone interested. While with Bortnyik, Vasarely continued his studies of lines and networks.

He left Hungary for Paris in 1930 and there, in the following year, made his first Optical, or as he calls them, proto-Optical, works. They were actually designs for textiles but, as he says, if pretentiously enlarged they might have constituted an anticipatory collection of Op art. They were followed (1933–8) by a series of what might be described as representational optical works: harlequins, zebras, tigers and Martians. These are not Optical in the fullest sense since the representational element keeps the picture from dissolving in the way a purely Op painting does, but they give an impression of movement by optical means. They do not present a moving object in its various phases of movement as Balla's *Girl Running along a Balcony* or Duchamp's *Nude Descending a Staircase* do. They do not imitate a moving picture ('mimeticism' Vasarely called it) but as he says, they convey movement by the 'aggressiveness with which the structures struck the retina'. After these works Vasarely abandoned Optical art until 1951. With the advantage of hindsight, he says (quite rightly) that these studies in

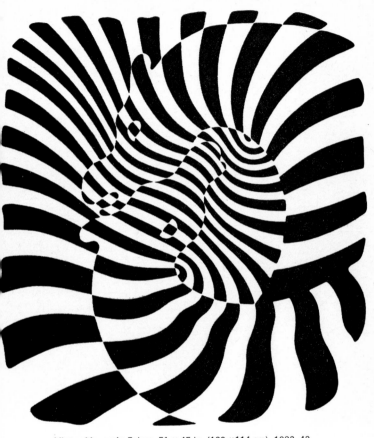

Victor Vasarely *Zebras*, 51 × 45 in. (129 ×114 cm), 1932–42
Denise René Gallery, Paris

◀ **Victor Vasarely** *Harlequin*, 22½ × 15¾ in. (57 × 40 cm), 1935
Denise René Gallery, Paris

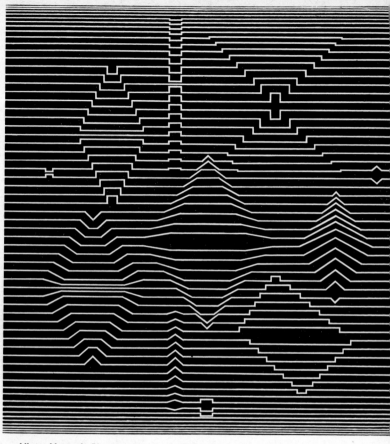

Victor Vasarely *Photographism Ibadan*, 64½ × 59 in. (163 × 149 cm), 1952–62
Private collection

movement were on the wrong track. However engaging these dancing harlequins and neck-rubbing zebras may be, optical effects are subordinated to representation.

During the war years Vasarely worked as a commercial artist. After the war he went through a brief Tachist, followed by a Symbolist phase. In 1947 he returned to geometrical abstraction. He recognized, as he says, that 'pure form and pure colour could represent the world'. By 1951 he had returned to his grids. By

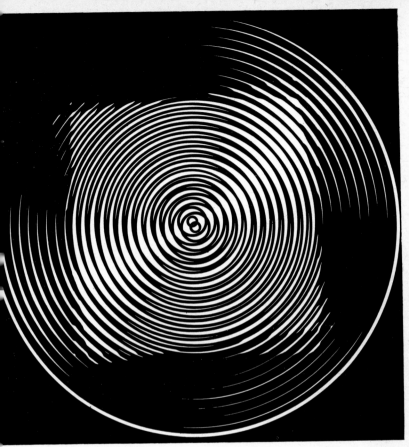

Victor Vasarely *Transparency*, 25½ × 19¾ in. (64·5 × 50 cm), 1953
Denise René Gallery, Paris

1953 he was back at his transparencies, and by 1954 at his Op-
tical paintings, or as he called them, 'Kinetic Works in the Plane'.

Not all these works are equally effective optically. Some of the
grids, such as the 'Photographisms', are what I shall call 'abstract-
illusionist' rather than Optical. They give the illusion of being
three-dimensional geometrical figures; the amount of optical
flicker is slight. The transparencies, on the other hand, have a
marked optical effect. This is impossible to illustrate with still

photography (though it may be hinted at), because the effect depends on one transparent sheet being moved over another. As the identical structures (in the illustration, concentric circles and a white square) slip over one another there is an enormously enhanced optical movement. Vasarely also made transparencies with a space between each layer (like the double-glazed windows of his youth) which he called 'Deep Kinetic Works'. These operate in much the same way as the superimposed 'transparencies' except that instead of moving one layer over the other the effect is achieved by moving from side to side in front of them.

In 1955 Vasarely, together with Soto and other artists concerned with movement, took part in an exhibition at the Denise René Gallery in Paris and issued a manifesto (known as the *Yellow Manifesto*) on the theme of 'plastic-kineticism' which might be translated as Optical art or Optical–Kinetic art. If one had to give a date for the beginning of the Op art movement, 1955 might be as good as any other.

Most of Vasarely's early works were in black and white. Since then he has turned to colour. His colour works are never quite so successful optically as the early black and white. But where colour is combined with differences of tone he has often managed to produce some subtle optical transpositions. If one can imagine the colours of *CTA 102 no. 4*, the ground is a uniform acid green and the ovals are a uniform red hue which varies in tone as it approaches the outer edges. The red and green reinforce each other since they are complementaries. The green is intensified most where the red is darkest and the red is intensified most where it is lightest. The result is that at its very centre, its heart, the picture glows with

Victor Vasarely *Ixion-1*, $31\frac{1}{2} \times 24\frac{1}{2} \times 6$ in. ($80 \times 64 \times 15 \cdot 2$ cm), 1954
Artist's Collection

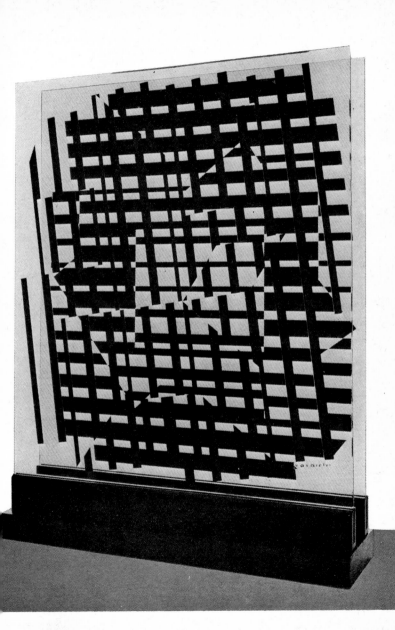

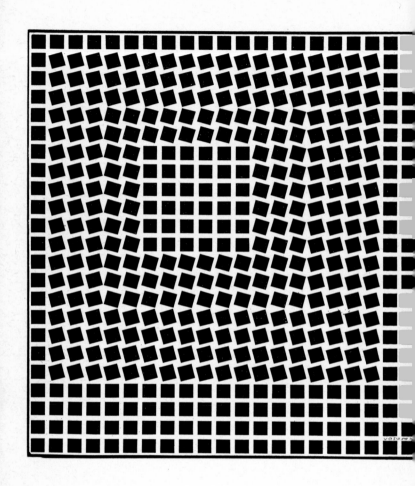

Victor Vasarely *Eridan-C no. 33*, 25 × 28 in. (63·3 × 72 cm), 1963
Denise René Gallery, Paris

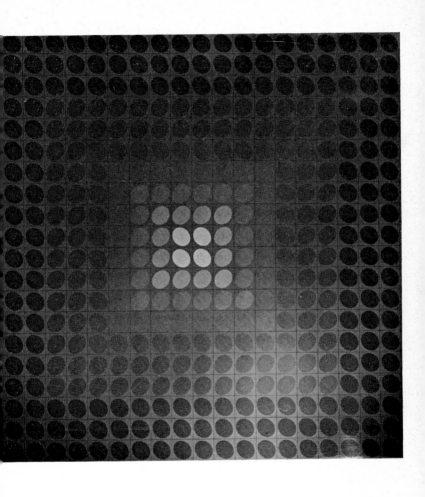

Victor Vasarely *CTA 102 no. 4,* 28 × 28 in. (72 × 72 cm), 1966
Editions Alecto, London

fire, while in its outer reaches bronze ovals are set in a field of smouldering green. But in his colour compositions, more than in his black and white, Vasarely wavers between Optical art and abstract illusionism. A recent work, entitled *TriDim-A,* gives the illusion of three-dimensional solids which are also what the psychologists call reversible figures, that is, figures which can be seen now one way, now another, now solid, now hollow; they are abstract-illusionist rather than Op.

The truth is that Vasarely is not a wholly committed Optical artist. His interests are wider. Yet no one has written more rhapsodically of Optical art than Vasarely.

The stake is no longer the heart but the retina . . . Sharp black and white contrasts, the unendurable vibration of complementary colours, the flickering of rhythmed networks and permuted structures, the optical kineticism of plastic components . . . the role of which is no longer to create wonder or to plunge us in sweet melancholy, but to stimulate us and provide us with wild joys.

('Planetary Folklore')

Victor Vasarely *TriDim-A,* 71 × 55 in. (180 × 140 cm), 1968
Denise René Gallery, Paris

J.-R. Soto *Repetition Yellow and White*, 75 × 51¼ in. (190 × 130 cm), 1951
Denise René Gallery, Paris

Soto, on the other hand, is a totally committed Optical artist, or, as
he might prefer to be called, Optical–Kinetic artist. He arrived in Paris
from Venezuela in 1950 with his head filled with Mondrian and a
desire 'to make Mondrian move'. In the following year he discovered
that the way to do this was by repetition. He worked with very
simple elements—triangles, squares and dots. In his earlier works,

J.-R. Soto *Metamorphosis*, plexiglass, 1954
Denise René Gallery, Paris

such as *Repetition Yellow and White*, the movement is limited ; the
elements were too large. Gradually with the elements reduced in
size—in some cases to rows of dots in series (he was interested in
serialism in music)—the movement increased and the elements lost
their individual identity. Soto was not interested in beautiful forms
as contemporary Parisian painters were, but in 'pure movement'.

He came a step nearer his goal when he made superimposed plexiglass sheets covered with dots and discovered that the impression of movement was greatly increased by placing the sheets at some distance apart. As the spectator walked in front of them, not only was the individual identity of the dots annihilated but also the distance between them. He had made what he called his transition from Optical to Kinetic art. This was in 1955 by which time Vasarely had also arrived at Kinetic works in depth.

Here it might be well to pause and consider the terms 'optical' and 'kinetic'. Vasarely regarded his two-dimensional as well as his three-dimensional works as both optical and kinetic. They are kinetic insofar as they move, or rather appear to move, and optical in that the impression of movement is brought about by certain physiological reactions. Soto makes a distinction between those works which give an impression of movement as a result of movement on the part of the spectator (these he calls 'Kinetic') and those which give an impression of movement without any movement on the part of the spectator (he calls these 'Optical'). The important difference for him is that in the former, the Kinetic works, 'movement and time-duration are directly experienced, becoming a fundamental constitutive dimension in my work'. But even in his Kinetic works *the effect is produced optically*—'the vibration is not felt as something tangible; it's purely optical, without physical substance'. The experience may be different (in the Kinetic works, the sense of movement is enhanced) but there are Kinetic works which do *not* involve any optical effects. Thus, though Soto's distinction is valid, his terminology may be confusing.

What Soto had discovered when he started to make his 'Kinetic' works is a phenomenon technically described as the 'moiré effect'. This calls for another digression. Moiré effect occurs when two identical, or almost identical structures, usually composed of lines, are placed one on the other but slightly out of alignment; or when one regular structure is placed on another; or even when a single unit is placed on a regular structure. The effect varies with the structures. Concentric circles of specific dimensions, when placed on straight lines, produce shadowy rings (Fresnel–Ring moiré); straight lines at a slight angle to one another produce waves or curves such as the Gaussian curves illustrated here; a straight line

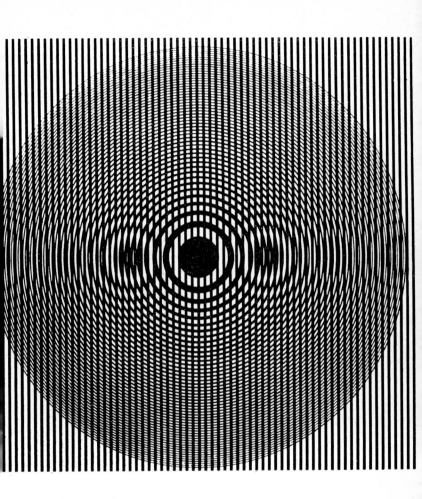

Fresnel-Ring moiré

Single line moiré

Gaussian curve moiré

placed diagonally across parallel straight lines will appear to be broken up into segments. It is not difficult to imagine what happens if the two superimposed sections are separated by a suitable space and one walks in front of them. The shadowy rings will expand, merge, disappear, reappear; the curves and waves will move across the structure, upwards and downwards; and the broken line may disintegrate still further, be reformed or even disappear altogether, if it falls along one of the background lines.

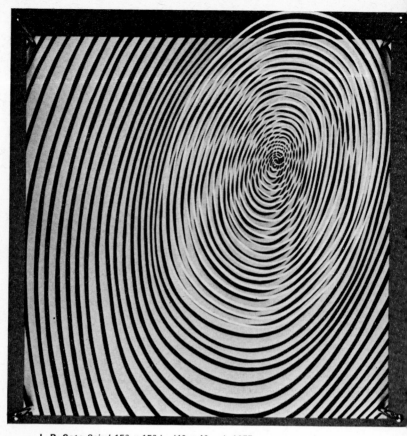

J.-R. Soto *Spiral*, 15¾ × 15¾ in. (40 × 40 cm), 1955
Tate Gallery, London

To Soto, who was interested in pure movement and the 'dematerialization' of forms, and who wished to take quite simple elements and transform them, moiré offered immense possibilities. One can see the use which he made of it in the superb early work, *Spiral*. It is not surprising that, having hit on this device, he has been exploring its possibilities ever since.

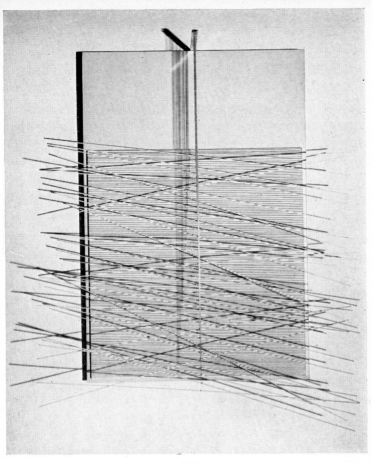

J.-R. Soto *Vibration Structure*, 1964
Denise René Gallery, Paris

In 1957 Soto made his first 'Vibration Structure'. This consisted of a background of black and white lines against which he placed a wire structure. Hitherto by means of the moiré effect he had succeeded in dissolving lines on a flat transparent surface. With his 'Vibration Structures' he dissolved a solid object, the wire structure. As one moves in front of it, the wire breaks up into little pieces

which later reunite, only to break up once more. Soto has made many variations of these 'Vibration Structures', using wooden or metal rods, often of different colours, which, being suspended by string, can be set in motion, thus adding to the effect. In recent years, he has filled whole rooms with these rods, and created a kind of optical environment. One has a feeling of moving through a forest or through high grass which dissolves in light. In a strange way one also gets a feeling of being in the presence of a sort of visual music. As the slender rods flicker against the moiré background it is as though one were sensing the visual equivalent of the twang of a guitar or a harpsichord. Soto regards these environmental works (he calls them 'Penetrables') as more in keeping with contemporary ideas than the traditional works which face us on the wall. 'We are immersed in the trinity—space—time—matter —as the fish is immersed in the water.'

Besides his 'Vibration Structures' Soto has made use of moiré in other ways. In his 'Relations', of which *Relationship of Contrasting Elements* is an example, he places coloured metal squares in front of a moiré ground. As the spectator moves in front of them, the edges of the squares flicker across the moiré lines. Though the squares do not appear to dissolve, the distance between them and the background becomes ambiguous, and they seem to float in an intangible space of their own creation.

J.-R. Soto *Relationship of Contrasting Elements*, $62\frac{1}{2}$ × 42 × 6 in. (154 × 106 × 15·2 cm), 1965
Tate Gallery, London

J.-R. Soto *Cube of Ambiguous Space,*
98½ × 98½ × 98½ in. (250 × 250 × 250
cm), 1969
Denise René Gallery, Paris

If, as George Rickey says, the primary source for the artistic use of optical phenomena is the painting and influence of Vasarely, Jack Burnham is probably correct in saying that 'the kinetic sensibility in Optical art owes its origins more to Soto than to any other artist'. At any rate, no one will question the fact that Vasarely and Soto were the pioneers of the Optical–Kinetic movement. Others, who were not themselves Optical artists, had an indirect influence on the movement. In Germany the monochrome paintings of Fontana, Yves Klein and Manzoni induced a new sensibility towards pure colour and light. The serial techniques of Max Bill and Lohse, with their repetitions of identical units and contrasting colours, had only to be carried a stage further in one direction to produce optical effects. On the other hand, in Britain, where the movement started slightly later, there seems to have been no direct influence from the continent, though British artists shared a common dissatisfaction with informal art and drew on the common seminal influence of the Bauhaus.

Optical art on the Continent

Optical art did not emerge on the Continent as a distinct movement but as part of a wider movement which, for the sake of convenience I have referred to as the New Tendency. Its main characteristics have already been described. One feature of the New Tendency which has not yet been mentioned however, is that many of its members at first worked in anonymous groups and called themselves by such names as Equipo 57, Group Zero, Gruppo N and Gruppo T, Groupe de Recherche d'Art Visuel, Nota and Effekt. The reasons for anonymity were various, but the fundamental reason was that they wanted to break with the traditional notion of the artist as a unique genius who produced undying masterpieces which called for respectful admiration on the part of the spectator. They did not want to intrude between the work and the spectator. They wanted the spectator to absorb himself in the work which would be as much a product of his responses as of the artist's creative genius. Since Optical art is the kind of art which depends on the spectator's response, a good deal of New Tendency art was Optical.

Most of the Optical works by New Tendency artists are either relief structures or moving objects, but there are also a few paintings. All the Groupe de Recherche began by making Optical paintings. Morellet persisted longer than the others and managed to achieve complex effects from starkly simple elements. His 'Tirets' (hyphens) of small lines, endlessly repeated, set up an almost inexhaustible number of relationships. On one occasion he made a structure of red and blue squares, chosen by picking out numbers from the Paris telephone directory, odd for the red, even for the blue, which laconically he called *Aleatoric Distribution.* The German artist Ludwig Wilding has also made some remarkable structures with lines. Almir Mavignier, a Brazilian artist working in Germany, produces contrasts of irradiation by building up white dots on a dark ground. In his later works these dots have grown into conical shapes, like stalagmites, which, by catching the light, intensify the illumination.

François Morellet *Tirets 0°–90°*, 55 × 55 in. (139 × 139 cm), 1960
Private collection

François Morellet *Aleatoric Distribution*, seriograph, $31\frac{1}{2} \times 31\frac{1}{2}$ in. (80 × 80 cm), 1961

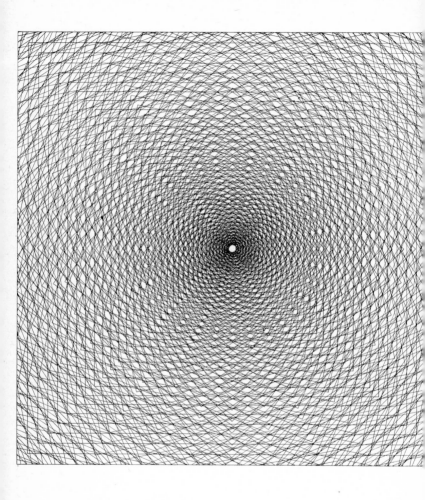

Ludwig Wilding *Line Drawing*, wood, acrylic, $31\frac{1}{2} \times 31\frac{1}{2}$ in. (80 × 80 cm), 1962

Almir Mavignier *Concave–Convex*, seriograph, $24\frac{1}{2} \times 24\frac{1}{2}$ in. (62 × 62 cm), 1966

Carlos Cruz-Diez *Transchromie*, 10½ × 11⅜ in. (26·5 × 28·7 cm), 1965
Artist's Collection

Carlos Cruz-Diez *Physichromie no. 260*, plastic, wood
and celluloid, 47⅝ × 24 in. (121 × 61 cm), 1966

Artist's Collection

The works of the Venezuelan artist Carlos Cruz-Diez, though strictly reliefs, could be treated as paintings. They are intensely Optical. About 1959 he became interested in the effects of colour radiation and reflected colour. By placing coloured slats on a coloured ground, he was able to get the colours to merge and

Carlos Cruz-Diez *Chromosaturation Pour un Lieu Public/Sortie du métro Odéon*, 1969, Paris

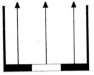

(a) Additive

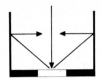

(b) Reflective

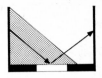

(c) Subtractive use of colour in Cruz-Diez's *Physichromies*

mingle. What one sees is not only the light reflected directly (fig. *a*) but also the mingled colours reflected from the sides of the slats (fig. *b*) ('Physichromies'). He later on used transparent coloured slats so that the coloured light coming through them transforms the pigment colours before they are reflected (fig. *c*). As he says, the result is that of a 'changing chromatic atmosphere and not that of plain colour simply painted in with a brush'. He has also succeeded in producing extraordinarily subtle colours by superimposing two sheets of coloured plastic ('Transchromies'). The slightest movement of one sheet over the other produces new colour combinations. In his latest works, ('Chromosaturations'), he, like Soto, has turned his attention to environmental art. He immerses the spectator in colour and either makes him see the world around him in colours complementary to those of his artificial environment or experience spectacular changes of colour as he moves from a room flooded with one pure colour into a room flooded with another. Thus, passing from blue to red, the red first appears orange (the eye, saturated with blue sees everything yellow) then clears, to take on a greenish tinge.

Heinz Mack *Light Dynamo*, $22\frac{1}{2}$ × $22\frac{1}{2}$ × $22\frac{1}{2}$ in. (57 × 57 × 57 cm), 1963
Tate Gallery, London

Heinz Mack, Getulio Alviani, Julio Le Parc, Karl Gerstner and
Martha Boto achieve optical effects by means of reflections from
polished metal. Mack and Alviani depend on the changes
brought about by the varying angle at which the light strikes their
metal structures. As the spectator shifts his position the structure

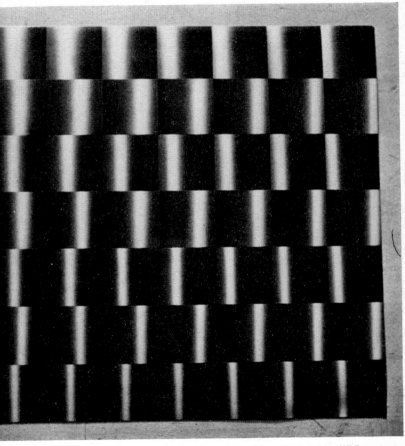

Getulio Alviani *Surface of Vibrant Texture,* aluminium 38½ × 38½ in. (97·5 × 97·5 cm), 1963
Denise René Gallery, Paris

dissolves in a luminous glow. Mack also uses engraved glass, placed in front of a revolving metal disc, to achieve the same effect. Le Parc, Gerstner and Boto, on the other hand, employ internal reflection and depend on either the movement of the spectator or on artificial motive power to secure an effect. By

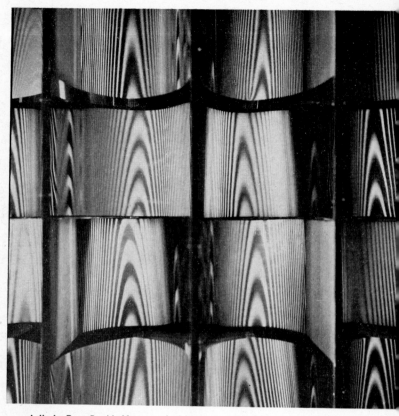

Julio Le Parc *Double Movement by Displacement by the Spectator* 48 × 48 × 9½ in. (122 × 122 × 24 cm). Detail. 1965
Denise René Gallery, Paris

internal reflection I mean the reflection of one part of the object, usually a structure of lines, by other parts. Movement, either by the object or by the spectator, distorts the lines and dissolves the surface. In Le Parc's *Double Movement by Displacement by the Spectator* the lines are concealed and one sees only the

Martha Boto *Luminous Polyvision*, 23½ × 23½ × 23½ in. (60 × 60 × 60 cm), 1965
Denise René Gallery, Paris

continually distorted reflections. The lines in Martha Boto's
Luminous Polyvision are caused by the shadows of incisions
in the metal. Gerstner uses plexiglass lenses and ambiguous
relationships between systems of lines to bring about dis-
tortion.

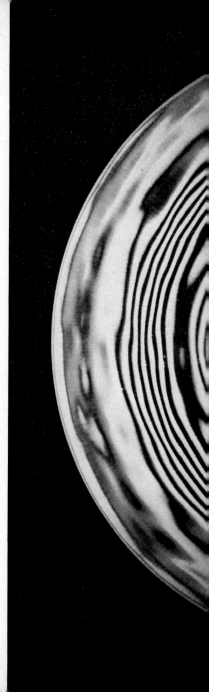

Karl Gerstner *Lens Picture no. 15*,
concentric circles behind plexiglass
lens 28⅜ × 28¹³⁄₁₆ × 7¼ in.
(72 × 73 × 18·5 cm), 1964
Albright-Knox Gallery, Buffalo. Gift of
Seymour H. Knox

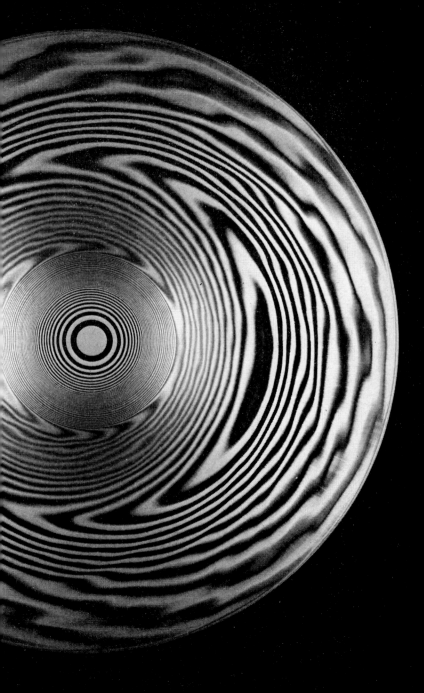

Other artists work with non-reflecting surfaces. Gunther Uecker uses nails. His *Spiral* produces an optical effect in much the same way as an Optical painting does. The nails melt into their shadows. Castellani's reliefs work in a similar way only in reverse; instead of the nails protruding, the canvas is stretched over them leaving hollows and ridges. The optical effect of some of Gerhard von Graevenitz's 'Objects with Moving Discs' is rather like that of Bridget Riley's *Fragment 9*. Even when static the discs appear to move. When moved in a random fashion, their movement becomes more frenzied. Tomasello's reliefs behave optically when viewed at a certain distance, on account of the regularity of the structure of the small cubes and their shadows, but viewed close to the cubes keep their identity. However, the effect when seen close to is equally interesting; the cubes cast subtle reflections across the surface, particularly from their inner or hidden face which is coloured. Some of Le Parc's structures have the same ambiguity of effect, though the orientation and varying depth of the wooden pegs give the structure a greater sense of movement. The same is true of Debourg's reliefs whose hollowed cylinders capture the light at various angles. On the other hand, the reliefs by Harmut Böhm, like those by Uecker, look and act like Optical paintings.

Gunther Uecker *Spiral,* $39\frac{1}{2}$ × $39\frac{1}{2}$ in. (100 × 100 cm), 1965
Collection Hon. Mrs Miriam Lane, Oxfordshire

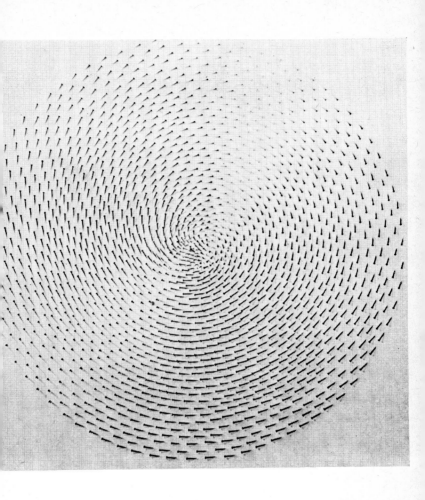

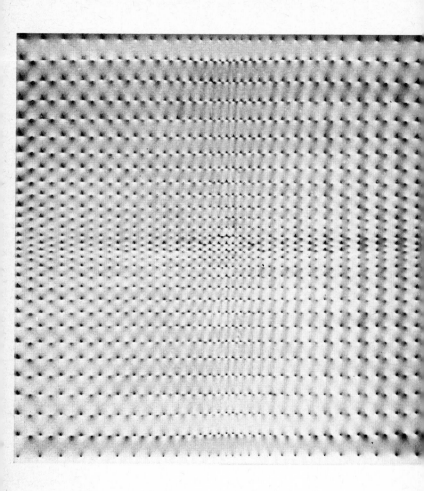

Enrico Castellani *Divergent Structure no. 4*, 31 × 31 in. (79 × 79 cm), 1966
Betty Parsons Gallery, New York

Gerhard von Graevenitz *Object with White Moving Discs,* iron and wood, 47¼ in. (120 cm) diameter, 1965

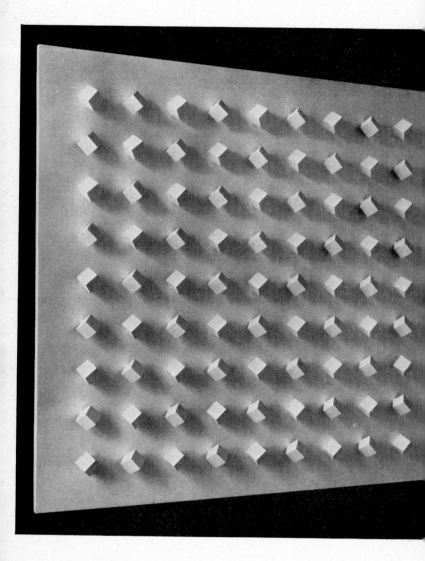

Luis Tomasello *Reflection no. 47*, 47⅝ × 47⅝ in. (121 × 121 cm), 1960
Denise René Gallery, Paris

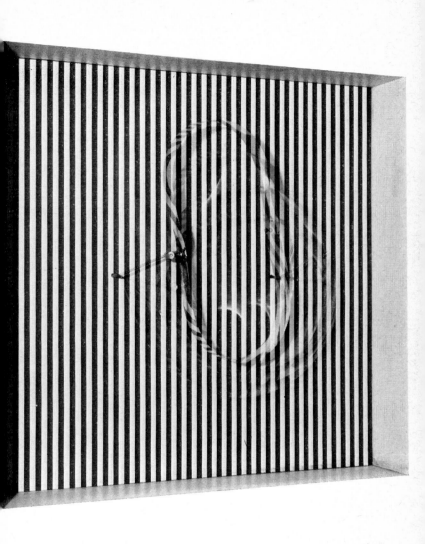

Julio Le Parc *Contorted Circle*, 1966
Denise René Gallery, Paris

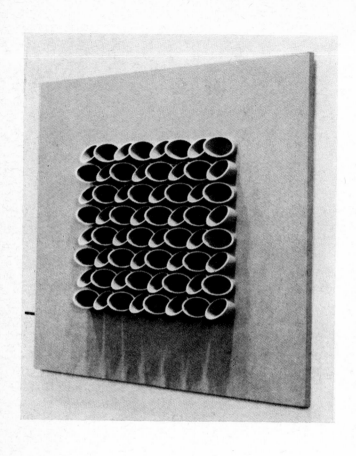

Narcisco Debourg *Perception*, painted wood, 36⅝ × 36⅝ in. (93 × 93 cm), 1967
Denise René Gallery, Paris

Hartmut Bohm *Light-Direction no. 135*, 1967
Artist's collection

Ludwig Wilding *Interference of Two Structures in Three Dimensions,*
plexiglass, wood, acryl, 31½ × 25½ × 4¾ in. (80 × 65 × 12 cm), 1963
Artist's collection

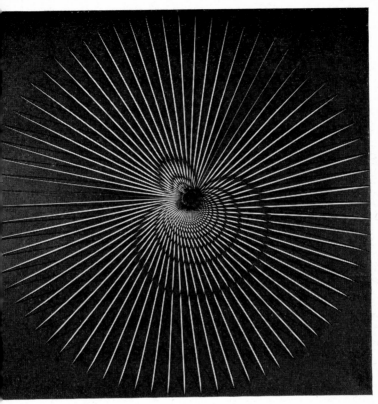

Jean-Pierre Yvaral *Interference A*, $47\frac{1}{4} \times 47\frac{1}{4}$ in. (117 × 117 cm), 1966
Denise René Gallery, Paris

Considerable and varied use has been made of moiré effects by continental artists. Wilding has been interested in moiré since 1955. He makes both superimpositions and reliefs. In most cases the basic pattern is extremely simple, but great richness of effect can be produced either by moving the structures or by moving in front of them. The moiré reliefs of Jean-Pierre Yvaral (son of Vasarely) retain their simplicity as their moiré pattern unfolds as

Joel Stein *Web in Movement*
Denise René Gallery, Paris

do those of Joel Stein. Stein achieves a moiré effect by passing light through revolving perforated discs which never quite coincide with one another. By contrast, the effects produced by Toni Costa's moiré reliefs are aggressive. Distorted squares burst out

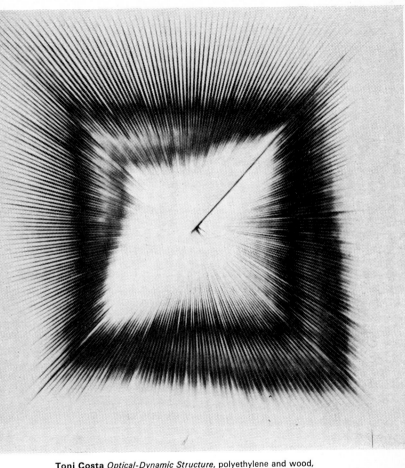

Toni Costa *Optical-Dynamic Structure*, polyethylene and wood,
$35\frac{1}{2} \times 35\frac{1}{2} \times 2\frac{3}{8}$ in. (90 × 90 × 6 cm), 1961
Private collection

from a centre of very great intensity of irradiation. Leblanc com-
bines moiré effects with colour mixture. This is achieved by using
strips of coloured plastic in a manner not unlike that employed by
Cruz-Diez.

101

Walter Leblanc *Torsions*, 1963
Maison des sourds-muets, Belgium

François Morellet *Successive Illumination*, 31½ × 31½ in. (80 × 80 cm), 1963
Denise René Gallery, Paris

In more recent years artists have taken to using light to produce optical effects. Morellet has made structures of light bulbs which are switched on and off at random, and Horacio Garcia Rossi uses the random illumination of plexiglass rods. The sudden

Horacio Garcia Rossi *Unstable Light Structure*, $39\frac{1}{2} \times 39\frac{1}{2} \times 15\frac{3}{4}$ in.
(100 × 100 × 40 cm), 1965
Denise René Gallery, Paris

appearance of light sources at different points across a structure
causes the eye to hop about and to experience the sort of baffle-
ment encountered in the presence of an Optical painting. Angel
Duarte, who has painted some lively Optical paintings, uses light

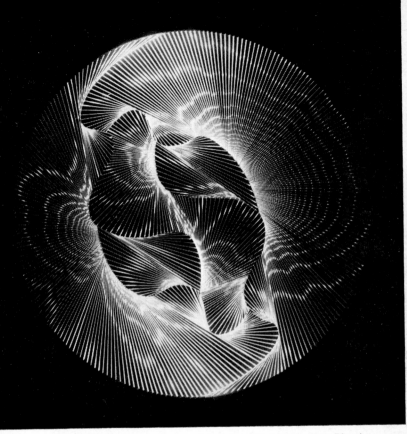

Angel Duarte *V10*, glass, neon and aluminium, $27\frac{1}{2} \times 27\frac{1}{2}$ in. (70 × 70 cm), 1963
Collection Marcelo Mastroiani, Rome

to obtain optical effects of great beauty, as in his *V10*. Here lines, incised on revolving glass, form interpenetrating patterns (sometimes moiré patterns) with areas of great luminosity which gradually dissolve into darkness. The effect of coloured light on

pigment colours has been used by Lily Greenham to achieve transformations of form. Since, for example, a red light on green will turn it black, while areas of red may seem to disappear, a pattern can be altered by changing the colour of the light playing on it.

We have already seen that optical effects can be obtained by the

o **Le Parc** *Continual Light Mobile*, 1960
ate Collection

action of light on moving objects, as in Gabo's *Kinetic Sculpture*. Le Parc uses this in his *Contorted Circle*, which is merely a loop set in rapid motion, and in his environmental 'Screens' of metal squares suspended on string, which gyrate at the slightest movement of the air and seem to dissolve in reflected light. Demarco has achieved some remarkable transformations of form

Hugo-Rodolfo Demarco *Animated Table,* 35 in. (87·5 cm) diameter, 1966
Denise René Gallery, Paris

Antonio Asis *Spiral,* metal on metal 39¾ × 39¾ in. (99·5 × 99·5 cm).
Detail. 1966
Denise René Gallery, Paris

and colour by setting objects in motion in special lighting condi-
tions. Variations in speed and the use of fluorescent paint and
stroboscopic light can not only change the shape but also the
colour of an object or make two objects appear as one object,
traversing a large distance. Movement brings about an interpene-
tration of forms, as in the 'Spiral' structures by Asis, consisting of
gentle pulsating metal springs.

Bridget Riley and British Op

British Optical artists differ from their continental counterparts in two respects. They are primarily interested in painting and they are more uncompromisingly Optical. No artist has explored the artistic possibilities of optical phenomena so relentlessly as the British artist Bridget Riley.

We have already seen that Bridget Riley found her way into Optical art through an interest in Neo-Impressionist techniques (as exemplified in her *Pink Landscape*) and from a desire to produce on the canvas a visual equivalent of energy. Even during a brief period of 'field-painting' in the early 1960s it was not so much the figure–ground relationships as what she called the 'bleep' between the forms that interested her.

Her first Optical painting, *Movement in Squares*, is typical of her method of working. She takes a unit, in this case a square, and, as she says, 'paces' it, that is, puts it through its paces, pulling it this way and that, squeezing it till it becomes almost a straight line or expanding it into a large rectangle. Triangles are paced through the various stages from acute-angled to obtuse-angled; circles are paced through elliptical and ovular shapes. This pacing is carefully controlled so that the distortions of the unit set up a definite rhythm. In *Movement in Squares* the maximum distortion at the centre produces a warping and buckling movement, like waves in a confined space, which dies down towards the edge of the picture. Although the structure of the picture appears to be loose and capable of indefinite extension, this is not so. The movement of the units is held strictly within the limits of the picture and any addition or extension would upset the rhythm and cause the picture to disintegrate. This is true of her other works, and, indeed, of all successful Optical pictures.

Like the space in a Mondrian or in most American paintings, the space in Bridget Riley's pictures is a shallow and open or non-focal space. But unlike the space in these other pictures, hers is a fluctuating or 'active' space; it operates, as she says, like the crack of a whip.

The optical effects produced by pacing units can vary greatly in

Bridget Riley *Movement in Squares*
Tempera on board, 48 × 48 in. (122 × 122 cm), 1961

intensity. Some of Bridget Riley's early paintings, those belonging to the 'Blaze', 'Disfigured Circle' and 'Twist' series, are extremely aggressive. The assault on the eye can be quite painful. As Anton Ehrenzweig wrote of them: 'We sometimes speak of "devouring" something with our eyes. In these paintings the reverse thing happens, the eye is attacked and "devoured" by the paintings.' Bridget Riley admits that these pictures may reflect an inner conflict which has since been resolved. The movement in the 'Blaze' pictures is far more complex than in *Movement in Squares*. The circles seem to grind into one another like cogs in a gear-wheel; the ridges suddenly become hollows and the hollows, ridges; there is an intense concentration of energy and illumination at the centre. In the 'Twist' series the effect is less intense. Though there is a shift from hollow to ridge, and though the upward-moving left-hand section grinds into the downward-moving right-hand section, the structure is open-ended and to that extent the tension is dissipated. In the 'Disfigured Circle' series the action is once more enclosed, but the tempo is slower. The sharp black and white contrasts still make an assault on the eye, but the shift from one plane to another is gentler.

Bridget Riley *Twist*, 48 × 45¾ in. (122 × 116 cm), 1963
Private Collection, USA

Bridget Riley *Disfigured Circle*, 44½ × 43½ in. (113 × 108 cm), 1963
Grosvenor Gallery, London

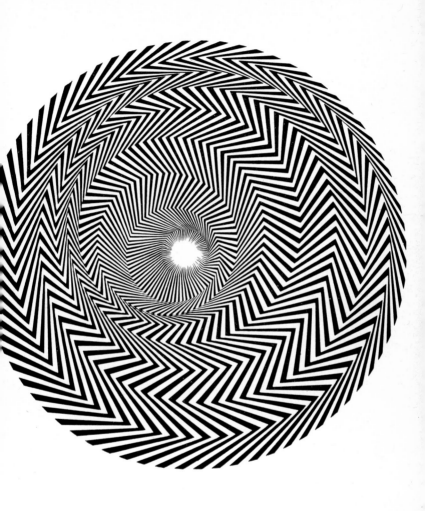

Bridget Riley *Blaze 1*, 42 × 42 in. (106 × 106 cm), 1962
Collection Mio Downyck, London

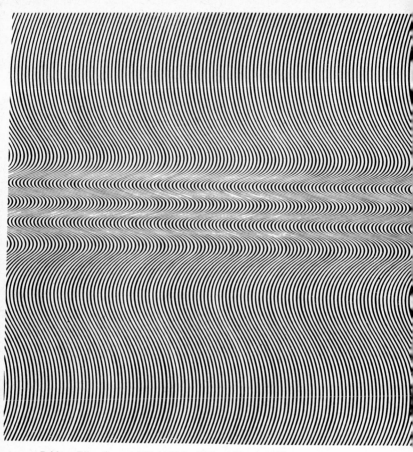

Bridget Riley *Current*, 58¾ × 58¼ in. (148 × 147 cm), 1964
Museum of Modern Art, New York

In subsequent works, which are predominantly structures of lines, the effect, though still strong, is still less intense. In place of angular lines, curves and waves predominate, as in *Current* and *Fall*. In these works there is a shift from the vertical to the horizontal, though there is movement in both these directions which acts as a sort of counterpoint. In *Current*, the lines themselves fall vertically and there is a vertical movement which gathers

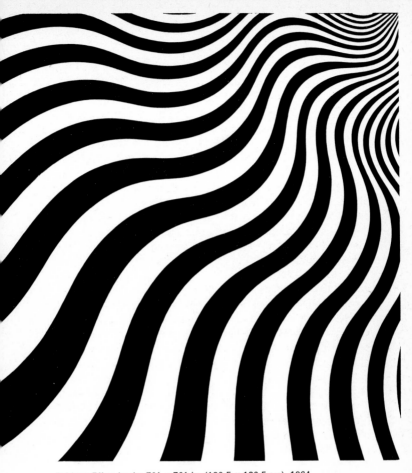

Bridget Riley *Intake*, 70¼ × 70¼ in. (180·5 × 180·5 cm), 1964
Collection John Powers, USA

momentum as it approaches the centre, then decreases. But the strongest movement is horizontal, across the crests and troughs of the waves. This horizontal movement sometimes creates bands of black and even coloured 'mist' which hangs before the canvas or moves slowly across it. In a work such as *Intake*, the movement is diagonally across the canvas; waves rising from the bottom left-hand corner break and return meeting others on their way up.

Towards the mid-sixties Bridget Riley moved away from the sharp contrasts of black and white towards tonal variation and eventually to colour contrast. The introduction of tone added a new kind of movement. The tempo (the speed at which the eye seems to move) varies according to the interval between tones: three beats (black, mid-grey, white) was rapid; five beats (black, dark-grey, mid-grey, light-grey, white) was slower; and so on. In *Deny 1* there is both tonal and colour variation, or, to be exact, real changes in the tone of the grey pigment of the ovals bring about apparent changes in the tone of the blue background. Thus, where the ovals are dark the background appears bright and where the ovals are light the background appears dark. There is also apparent movement in depth; where the background is dark it seems to sink back and where it is bright, it advances.

From tonal contrasts Bridget Riley went on to pure colour contrast without tonal variations. The use of colour presented peculiar problems of its own, and to cope with these she at first limited the colours to two and kept the structures relatively simple. Later other colours were introduced, but there are rarely more than three, unless the additional colours mediate between two dominant colours, as in *Late Morning* where the basic colours are red, blue and green with eight additional hues between blue and green. The structure is as simple as it can be: parallel vertical lines. In more recent paintings, such as *Orient IV*, the structure is slightly more complex. In place of the parallel lines there are alternately ascending and descending elongated triangles. And there is a further complication: one of the coloured bands, the magenta, crosses the other two, which are turquoise and mustard. The result is a continuous colour change, down the whole length of each band. But the most interesting colour effects happen within the white triangles. The reactions which take place between the coloured bands induce a kind of disembodied colour in the white areas. This is golden in the ascending triangles and green in the descending ones, and it varies in intensity throughout the length of each triangle, being most intense about the central line of the picture. By repeating the triangles across the canvas this colour induction is intensified, and, because the induced colours react with the pigment colours, there is a continuous process of colour

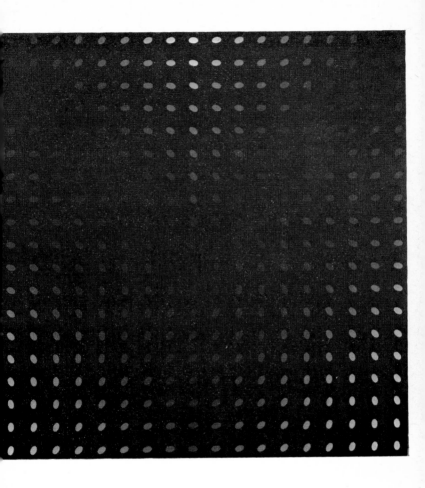

Bridget Riley *Deny 1*, $88\frac{1}{2} \times 88\frac{1}{2}$ in. (224 × 224 cm), 1966
Chase Manhattan Bank, New York

transformation. As in so many of Bridget Riley's paintings, these subtle effects may at first be missed; it is only when one realizes that an area which appears coloured is in fact white that one becomes aware of the complexity of what otherwise seems a very simple and unadventurous painting.

Bridget Riley's work is a product of exploration and calculation. From *Movement in Squares* to her latest colour pictures, she has continued to pace the various units with which she works until she has discovered their potential and exhausted their possibilities; and each new discovery suggests new fields of exploration. When, in 1968, she won the prize at the Venice Biennale, Edward Lucie-Smith wrote in *The Times*:

There can be few modern artists who have moved more logically from one phase to another without giving the impression that the work they were currently engaged upon is in some way incomplete . . . There never seems to have been a phase of her career when she felt at a loss as to where to go next.

In her method of work and in her attitude to her art, Bridget Riley is typical of British Optical artists. The British, unlike the New Tendency artists, did not issue manifestos, nor did they claim to present a new sensibility more in keeping with the spirit of a scientific age. As Jeffrey Steele says, the only piece of dogma to which they all subscribe concerns 'the necessity to expunge from our work all traces of the individual artist's "touch" or handwriting'. In trying to follow through this dogma they hit upon, almost by accident, the optical effect. 'The very vigour with which the qualities of *belle peinture* were eliminated of itself brought in a new unsolicited phenomenon, calling for special attention, the optical effect.'

Steele himself had at first been attracted to Constructivism and Neo-Plasticism, but while in Paris in the late 1950s he came into contact with the works of Albers, Max Bill, Lohse, Vasarely and Soto. This produced in him a resolution to proceed by controlled and logical experiment, but it was not till he returned to Cardiff and isolation that he can be said to have discovered Optical art. 'I began to try, in paintings, to balance numerous possibilities for appraisal in order to block a final resolution, thus bringing the spectator's optical mechanism into play . . . as in ju-jitsu one's opponent's strength is used against him.'

Bridget Riley *Orient IV*, 88 × 127 in. (223 × 322 cm), 1970
Rowan Gallery, London

Until quite recently, Steele worked exclusively in black and white. Colour, he says, would interfere with the factors of light and movement. The factor of movement is not as strong as in the works of Bridget Riley, but the factor of light is quite outstanding. In *Divertissement* there is a concentration of irradiation at the centre which gradually diminishes and then begins to build up again at the edges. It is a shimmering light due to the flicker caused by the regular changes in density of the lines. But in spite of the light and the movement and the slight angle at which it is tilted, the picture has great stability. Steele never allows the optical effects to take control. He likes to keep a balance between them and the surface pattern so that the spectator's attention can shift from the one to the other. The same balanced tension is to be found in *Lavolta*, where the heavy, dark diagonals hold the irradiating cross in check. In his later works the interplay of light and movement becomes increasingly subtle. Through the main movement of light and line in *Sub Rosa*, there is a counter-movement of interweaving circular forms.

Unlike most other British artists, Steele works according to a system. The choice of the system is spontaneous and intuitive but once chosen he adheres to it. He cannot foresee what the finished picture will look like, but, if it is not to his liking, he changes the system. As he says, 'if you alter the picture, you may have a nicer picture. But if you alter the system, you establish a principle on which you can build.'

Jeffrey Steele *Divertissement*, 30 × 22 in. (76 × 56 cm), 1963
Private Collection

123

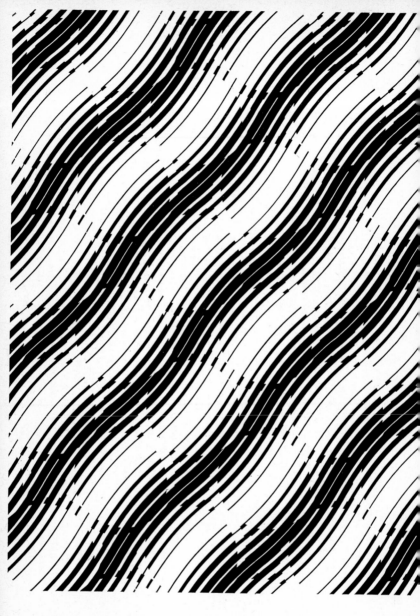

Jeffrey Steele *Sub Rosa,* 48 × 36 in. (122 × 91 cm), 1966
Collection Arne Larsson, Stockholm

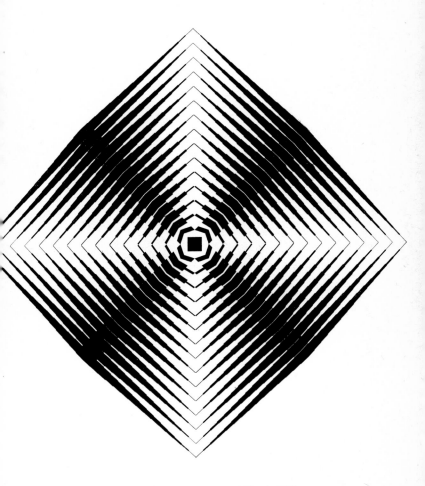

Jeffrey Steele *Lavolta*, 57 × 57 in. (144 × 144 cm), 1965
Stirling University, Scotland

Peter Sedgley *Trace 7*, 63 × 63 in. (160 × 160 cm), 1964
Max Simpson Collection, USA

Peter Sedgley, on the other hand, has been interested from the
beginning in the interaction of colour and form, and, although he
works within a strict colour scale, he does not employ a system.
In a work such as *Trace 7*, composed of concentric yellow circles
cut by white lines (right-angles) on a green ground, the green
varies across the picture according to the distance between the
lines and circles. It is often hard to believe that the green is a

Peter Sedgley *Phantom*, 48 × 48 in. (147 × 147 cm), 1966
Richard Feigen Gallery, New York

homogeneous tone and hue throughout. The moiré pattern,
(Fresnel Ring moiré) is a sort of bonus which had to be carefully
controlled—it is more conspicuous in a black and white reproduc-
tion than in the actual picture.

Sedgley has always had a preference for circular forms. The
circle is, as he says, anonymous; it does not vary in outline and it
allows the spectator to concentrate on the colour. In his earlier

circular target pictures the contours are precise and hard. When painted on a black ground they seem to revolve and pulsate. This pulsation was intensified when Sedgley began to use soft edges and the colours merged into one another. The rate of pulsation is controlled by the area and intensity of the colour. Since he uses a scale based on the spectral colours and works strictly through this scale—violet, blue, green, yellow, red—a definite tempo is set up according to the gentle or abrupt manner in which one colour modulates into another. The use of white (as a sort of pause) enables him to repeat a colour without interrupting the series. His use of colour is, therefore, not unlike that of a musician's use of sound; musical analogies are almost unavoidable.

In recent years Sedgley has become progressively absorbed by the possibilities offered by coloured light. This interest began quite accidentally when he was fitting out his studio for evening showings. While trying to find a form of light which approximated most closely to daylight, he became aware of the varying effects of different lights on his targets. He experimented with red, yellow and blue filters. The results, as can be expected, were remarkable. The effect of coloured light on coloured pigment, as we have already seen, is not only to transform the hue but to turn some colours black and make others disappear. By programming the coloured light, he was able to control the rate at which these colour transformations take place and, in consequence, the rate at which the targets expand and contract, pulsate and rotate. He next made moving target pictures ('Videorotors') covered with small patches of fluorescent paint. As the picture moves at varying speeds the patches coalesce, their colours change, as does their direction; some rows move rapidly, others slowly; some seem to move in opposite directions to the rest, others to stand still. An intricate ballet of movement and colour changes takes place. Further complexity is introduced by the addition of ultra-violet and stroboscopic light. In his most recent work he is quite literally painting with light, producing the most subtle colours by means of light combinations and shadow.

Peter Sedgley *Videorotor*, 60 in. (151 cm) diameter, 1968
Richard Feigen Gallery, New York

Sedgley has often been compared to the Polish painter, Wojciech Fangor, who also paints target pictures. Though Fangor spent some years in England, they both arrived at their target pictures independently. In spite of superficial similarities there are marked differences between the two kinds of picture. Fangor did not work to a colour scale and he usually placed his targets on a light ground. But the important difference is in their effect. Fangor's pictures tend to draw the spectator inwards and absorb him in a mysterious and sometimes frightening manner. He is primarily interested in space rather than in optical effects. He was rather surprised to discover that he was regarded as an Optical artist. 'For me,' he says, 'painting is a kind of reverse illusion of perspective. I build on the problem of the spectator in space, not outside the picture.'

Some British Optical artists, like Michael Kidner, have now moved out of the field of Optical art. Kidner was concerned with liberating colour from form and did so by using overlapping bands of colour which created a moiré pattern. But he found that his attempts to produce a pure sensation of colour more often than not resulted in a stronger structure and he is now occupied with the structural relationships of individual forms. Peter Schmidt, on the other hand, is interested in serial techniques, applying black and white or coloured units, according to systems which involve random selection (rather like Morellet's *Aleatoric Distribution*). The results are usually optical and he often succeeds in liberating pure and subtle colours. Don Mason achieves similar results by means of slowly changing light passed through structures of perspex tubes. Research into optical colour mixture has recently been carried out by Sidney Harry with some remarkable results. The interest in optical effects among British artists has thus in recent years become more diversified and seems to be moving in the direction of Optical relief and the optical use of light.

Wojciech Fangor *E.10,* 50 × 50 in. (127 × 127 cm), 1966
Grabowski Gallery, London

Optical art in America

Optical art has not had anything like the vogue in America, either among artists or critics, that it has had in Europe. In fact, it has met with downright hostility from both. It offended against one of the current dogmas; it disrupted the picture surface, and surfaces are still sacrosanct.

Some artists, however, indulged in this un-American activity. One reason for this was the presence and influence of Albers, who came to America in 1933 when the Nazis broke up the Dessau Bauhaus. If one were to sum up Albers' teaching and practice in one sentence, it would be his repeated assertion: 'The source of art is the discrepancy between physical fact and psychic effect.' The physical fact is the colour or line on the canvas or paper; the psychic effect is how it appears. Two colours may appear as one; the same colour may appear as two or more; a structure of lines may change its direction. These psychic effects are illustrated by his three famous series: 'Structural Constellations', 'Graphic Tectonics' and 'Homage to the Square'. In my opinion (which, I admit, is a minority opinion) neither the 'Structural Constellations' nor the 'Homage to the Square' series are Optical as that term is used in this book.

The 'Structural Constellations' are what psychologists call impossible figures, that is, figures which could never be constructed. They are also reversible figures. In our illustration, the box-like structure can be seen in different ways. What in one view appears as an outer wall, may appear in another view as an inner wall. This change of viewpoint sets the figure in perpetual motion. As Albers claims, he can make a picture move without real movement. But this is not optical movement; the surface is not disturbed; there is merely a change of viewpoint. In the 'Homage to the Square' series the juxtaposition of four concentric coloured squares brings about an alteration of the colour of each square. But again the picture surface is hardly disturbed because the colour differences are carefully modulated, the intermediate squares mediating

Joseph Albers *Structural Constellation: Engraving no. 30*, $25\frac{1}{2}$ × 19 in.
(65 × 48·3 cm), 1955
Denise René Gallery, Paris

Joseph Albers *Graphic Tectonics*
Private Collection

between the outer and inner squares. That there are continual
alterations of colour cannot be denied, but these are scarcely
perceptible. Perhaps, the difference between this and the kind
of colour changes which occur in Optical paintings is only a
difference of degree. Albers calls his art 'perceptual', and, insofar
as this encompasses a wider range of visual phenomena, this is an
accurate enough description. But he also believes that Optical
art is restricted to effects produced in the retina alone, which is

Joseph Albers *Homage to the Square: Departing in Yellow*, 30 × 30 in.
(76 × 76 cm), 1964
Tate Gallery, London

not so. The distinction is not, as he thinks, between retinal stimulus and post-retinal or psychological response but between the disruption or preservation of the picture surface. Albers' art includes both, and he is simultaneously acclaimed as the champion of Optical and anti-Optical art.

In his 'Graphic Tectonics' both optical effects, in the narrower sense, and perceptual effects are to be found together. As in the 'Structural Constellations' there is a possible change of viewpoint;

these linear structures can be read either as pyramidal forms or as corridors leading to a distant aperture. But, because of the optical flicker produced by the repetition of lines, the whole picture, and not just elements in it, can be set in perpetual motion.

It is interesting that in the work of his pupil, Richard Anuszkiewicz, both forms of perceptual art, that is, the kind of abstract illusionism of the 'Structural Constellations' and the more strictly (or as Albers would say, the narrower) Optical art of the 'Graphic Tectonics' can be found. An early picture like *The Well at the World's Eye* gives a powerful impression of receding space without any noticeable optical effect. In other paintings there are either marked colour changes or intense irradiation or both.

Union of the Four can be described as a red ground criss-crossed by a network of green, blue and violet lines. The green dominates along the diagonal axes of the picture. Where the violet dominates four faint squares are formed. The four corners of the picture are dominated by the blue. According to which colour dominates so the quality of the red changes—from bright red on the diagonals to dark red in the squares and orange-red in the corners. These effects are induced optically since the pigment red is uniform throughout. But the lines are also affected by the red, and glow or fade continuously. The continual changes of colour bring about a continual change of form or pattern ; the four squares, in particular, alternately come into prominence and sink back, thus, presumably, fulfilling their title role.

In *Division of Intensity* the basic form is again the square, and the effect, variations in luminosity, is produced by lines. The concentration of light at the corners of the inner square seems to suffuse all the lines, and the lines, as they fan out and converge, produce not only an optical flicker but also an unstable movement in depth.

Bill Kommodore also produces concentrations of luminosity by means of converging lines, as in his *Sun City*; but, whereas in Anuszkiewicz's picture the space is restricted, in Kommodore's it is limitless, as befits the title. Kommodore accidentally discovered the possibilities of optical effects when some of his paintings of squares produced after-images. This, he says, caused him to realize that this was the only way form can develop. Henry Pearson

Richard Anuszkiewicz *Union of the Four*, 52½ × 50 in. (133 × 127 cm), 1963
Collection Mrs Frederick Hilles, New Haven, Conn. Courtesy Sidney Janis Gallery, New York

Richard Anuszkiewicz *Division of Intensity*, 48 × 48 in. (122 × 122 cm), 1964
Martha Jackson Gallery, New York

Bill Kommodore *Sun City*, 72 × 64½ in. (182 × 154 cm), 1966
Howard Wise Gallery, New York

Henry Pearson *Black and White,* 78 × 78 in. (198 × 198 cm), 1964
Stephen Radich Gallery, New York

discovered the optical possibilities of lines from the maps he used
in the Air Force. Unlike Anuszkiewicz and Kommodore his art is, as
he says, a 'surface art', creating surface movement. Any suggestion
of cracks, wrinkles, mountains or valleys are contrary to his

Reginald Neal *Square of Three, Yellow and Black*, 32 × 32 in. (81 × 81 cm), 1964
New Jersey State Museum

intentions. Reginald Neal (British by birth) is another artist who works with lines to create a surface movement, less subtle and more obviously optical than Pearson's. Another artist who uses structures of lines, both sensitive and delicate, like Pearson's, is

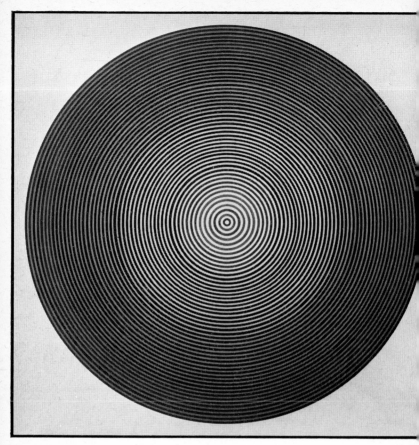

Tadasky *A101*, 52 in. (129 cm) diameter, 1964
Museum of Modern Art, New York

Julian Stanczak. The structures form overlapping systems which produce a moiré effect and induce subtle colour changes. Like Anuszkiewicz, Stanczak studied under Albers at Yale. The Japanese-born artist Tadasky also works with structures of lines, mostly concentric circles or targets, but they are different in feeling from any of the others so far mentioned. The movement is gentle and the mood induced contemplative.

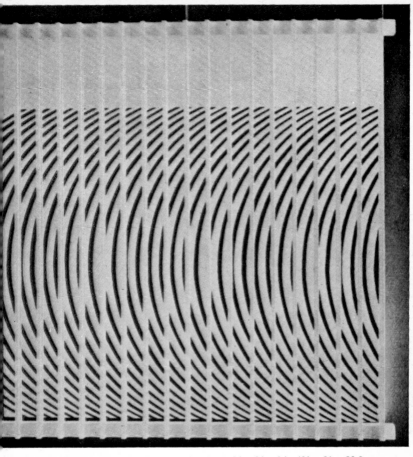

John Goodyear *Black and White Waves,* 24 × 24 × 9 in. (61 × 61 × 22·8 cm), 1964
Private Collection

A number of American artists have made Optical reliefs and light structures. John Goodyear suspends a series of grills or gates, one in front of the other. As they swing to and fro they create not only an optical flicker (like passing quickly in front of a railing) but give a feeling of spaciousness and of light. Levinson has made a number of moiré structures, but more recently has taken to using perspex rods tipped with luminous tape which glitter as the spectator

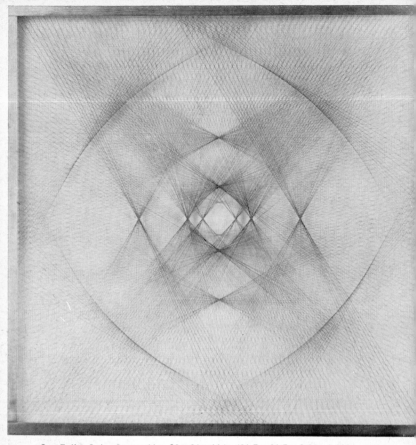

Sue Fuller *String Composition*, 36 × 36 × 1½ in. (91·5 × 91·5 × 3·8 cm.) 1964
Tate Gallery, London

Len Lye *Roundhead*, 1¾ in., set of concentric rings (named after the
male hormone—which also consists of a set of concentric forms), 1963
Private Collection

moves. The structures of very fine wires by Sue Fuller also have an
optical effect when caught in light as the spectator moves in front
of them. And the moving rings by Len Lye may be considered op-
tical in effect since they create luminous forms as they rotate.

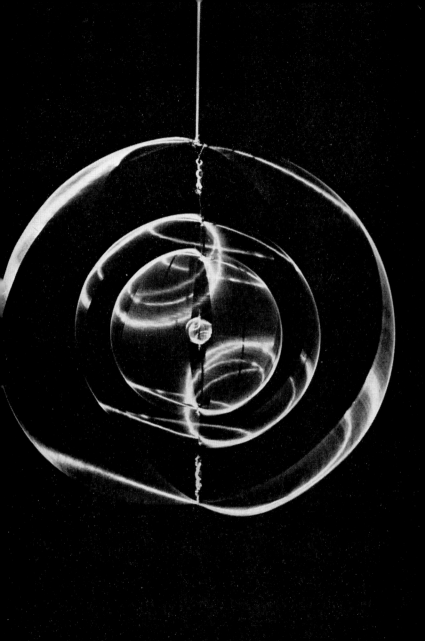

There is one American group, Anonima, which not only lives up to its name but is the only surviving group anywhere in the world. Its founder members are Edwin Mieszkiewski, Ernest Benkert and Francis Hewitt.

Apart from the artists already mentioned, there are some who have been regarded as Optical artists but would probably not accept this title. The most interesting case is that of Larry Poons. Some of Poons' works, like *Northeast Grave,* seem to have as much optical movement as any Optical painting. Don Judd goes so far as to say that he is the only artist who has done anything with optical effects. Poons himself, however, is contemptuous of Optical art. 'It is easy,' he says, 'to forget about painting and just make one of these optical things.' The truth is that no clear boundary-line can be drawn between Optical art and what Albers would call Perceptual art. Insofar as there is a line to be drawn it would seem to be between those works in which the surface is preserved and respected, and those in which it is not. In Poons' paintings, as, in those of Jeffrey Steele, for instance, the balance is a fine one. The same might be said of some paintings by Ellsworth Kelly, Frank Stella, Molinari, Gene Davis, Libermann, Feeley, Feitelson and Tousignant. It is not possible, as these artists think, to put colour on canvas and make it stay put. Optical movement and optical change is bound to occur, and their works would be the poorer if they did not. But these movements and changes can be checked or allowed to develop; it is a matter of degree. This in the long run is often all there is to distinguish Perceptual from Optical art.

Larry Poons *Northeast Grave*, 90 × 80 in. (228 × 203 cm), 1964
Collection Joseph H. Hirshhorn, New York

Applied Optical art

Optical art has often been accused of being little more than basic design or psychology-textbook illustration, so its proper fate should be to end up on the ad-man's or dress designer's drawing-board. This is in fact what happened. Here was an artform which was what every good dress or advertisement should be—eye-catching.

More often than not whole pictures were transferred to fabric without any regard for the effects they would have on the unfortunate wearer. Only one designer, to my knowledge, succeeded in applying optical effects in a way that harmonized with the figure and movements of the wearer. That was Alviani. The dresses were made up by Germana Marucelli. For the rest, they trivialized Optical art without much gain to *haute* (or even *basse*) *couture*. Of course, it was fun. As Jeffrey Steele, who suffered more than most, put it : 'I should hate to have missed any of the life experiences which the Op art boom brought, seeing girls actually *wearing* my paintings.' His *Baroque Experiment* appeared on a gown in one advertisement over the caption : 'Optical art—the *trompe l'oeil* play of patterns in black and white—stolen from the smart art scene and put onto fabric.' 'Stolen' is probably the only completely accurate word in that sentence. This picture reappeared in another advertisement the following year, this time on a bikini, with the sinister motto : 'Take it off (this is *last year's* swimsuit).'

Op art fared slightly better at the hands of the ad-men. The durable 'Woolmark' owes its inspiration to Optical art. By way of compensation, one of Steele's pictures has a permanent place on a billboard outside Cardiff station.

Getulio Alviani *Dress*
Galleria del Deposito, Genoa

New York Times advertisement

Jeffrey Steele *Baroque Experiment: Fred Maddox*, oil on canvas,
60 × 40 in. (152 × 101 cm), 1962–3
Collection Hon. Anthony Samuel

What is surprising is that more use has not been made of Optical art in interior decoration. But perhaps it would be too hard to live with, and, for Optical art to be effective, scale is all important. Yet there was a rather splendid use of colour Op in one of the rooms in Losey's film *Modesty Blaise*.

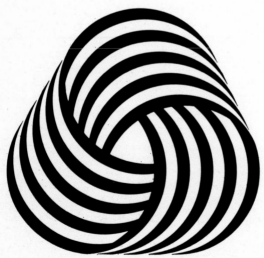

The Woolmark

Conclusion

The instant popular success of Optical art—unique, perhaps, in the history of art, since most new movements arouse initial hostility—was balanced by a rather cool reception from critics and artists. It was not art, they said, but glorified basic design or experimental psychology. It was also said to be unpainterly, since it destroyed the picture surface, mindless, lacking in expressive or intellectual content, a mere titillation of the senses. It had all been done before. Its imminent demise was predicted and eagerly awaited.

There was an element of truth in most of this criticism. What attracted the greatest attention was certainly not always the best in Optical art, neither the best works nor its more valuable aspects. Optical artists were only too painfully aware of this. But behind the superficial excitement of Optical art there was a serious purpose. Bridget Riley is surely right when she says: 'I am absolutely certain that optical painting has added something to the language of formal art . . . which cannot be ignored or eradicated . . . in the same sense that Cubism added something to a concept of space which having been assimilated cannot subsequently be discounted.' As I have tried to show, Optical art belongs to a tradition which has its origins in the preoccupations with colour which characterized the work of Delacroix, the Impressionists and the Neo-Impressionists. These preoccupations are, after all, central to pictorial art.

It may be said that Optical artists have gone too far, that their interest in the mechanism of vision is altogether too narrow. If this is so, then it is an accusation which cannot be levelled at Optical artists alone. It is characteristic of many, if not most, artists today that they limit the scope of their art in order to explore visual phenomena in greater depth and with greater concentration and intensity. Ockham's phrase, 'less is more', is rather often heard these days. A limitation in scope need not lead to a limited result. As Soto says:'It would be a mistake to see in the very work before you the object of my art. *The work is there only as a witness, a sign of something else.*'

153

As against the criticisms of Optical art, there are also somewhat exaggerated claims made on its behalf. It is said to be the art of a scientific age, which introduces a new concept of the work of art, of the role of the artist and the spectator, and, indeed, of man himself. No longer do we have unique geniuses making unique masterpieces which require a lifetime's training and erudition to appreciate. Optical art, or Optical–Kinetic art, appeals to our ordinary sensibility and invites us to participate in the production of the work on all levels, physiological, perceptual, intellectual, social.

There is an element of truth in this too. But it would be more accurate to say that Optical art makes us more aware of the processes which are at work in all appreciation of art. Undoubtedly the element of randomness which is a feature of some Optical art subtly changes our notion of what a work of art should be ; and no doubt Optical art, like any other form of living art, reflects something of the age which produced it ; but to say that one can come to it with innocent eyes is sheer self-deception. Perhaps more people enjoy Optical art than enjoy other forms of 'geometrical abstraction' and they certainly do not have to bring to it the kind of knowledge required to understand paintings of biblical or classical subjects ; but if Optical art has anything more than superficial dazzle, then it will call for a sensibility developed to some degree. As for the unique geniuses and their undying masterpieces, it is doubtful if any admirer of Optical art would seriously suggest that the names of Vasarely, Soto, Bridget Riley or Le Parc are soon to fade from our memories.

Bibliography

Barrett, Cyril *Op Art* Studio Vista, London 1970; Viking Press, New York 1970

Carraher, Ronald and Jacqueline Thurston *Optical Illusions and the Visual Arts* Studio Vista, London 1966; Reinhold, New York 1966

Compton, Michael *Optical and Kinetic Art* Tate Gallery, London 1967; Arno Press, New York 1968

Oster, Gerald *The Science of Moiré Pattern* Edmund Scientific Company 1959

Sausmarez, Maurice de, *Bridget Riley* Studio Vista, London 1970; New York Graphic Society, Connecticut 1971

Selz, Peter *Directions in Kinetic Art* University of California Press, Berkeley, California 1966

Vasarely, Victor *Victor Vasarely* Griffon, Neuchâtel 1965

Articles

Albers, Josef 'My Course at Ulm' April 1967 *Form 4*

Clay, Jean:

 'Soto' November 1965 *Signals*

 'Vasarely; A Study of his Work' May 1967 *Studio International*

 'Cruz-Diez' 1969 catalogue introduction to a one-man exhibition at the Denise René Gallery, Paris

 'Soto' 1969 catalogue introduction to a one-man exhibition at the Stedelijk Museum, Amsterdam

Oster, Gerald and Yashumori Nishijima 'Moiré Patterns' May 1963 *Scientific American*

'Op Art: Pictures that Attack the Eye' October 1964 *Time*

Seitz, William C. 'The Responsive Eye' 1965 catalogue introduction to the exhibition at the Museum of Modern Art, New York

Soto, J.-R. and Guy Brett 'Dialogue' November 1965 *Signals*

Steele, Jeffrey 'Cicerone' Winter 1967 *Anglo-Welsh Review*

Sylvester, David 'Bridget Riley' March 1967 *Studio International*

Thompson, David 'The Paintings of Bridget Riley' June 1968 *Studio International*

Index

Numbers in italics refer to pages including illustrations

STUDIO VISTA | DUTTON PICTUREBACKS

edited by David Herbert

British churches by Edwin Smith and Olive Cook
European domestic architecture by Sherban Cantacuzino
Great modern architecture by Sherban Cantacuzino
Modern churches of the world by Robert Maguire and Keith
 Murray
Modern houses of the world by Sherban Cantacuzino

African sculpture by William Fagg and Margaret Plass
European sculpture by David Bindman
Florentine sculpture by Anthony Bertram
Greek sculpture by John Barron
Indian sculpture by Philip Rawson
Michelangelo by Anthony Bertram
Modern sculpture by Alan Bowness

Art deco by Bevis Hillier
Art nouveau by Mario Amaya
The Bauhaus by Gillian Naylor
Blake the artist by Ruthven Todd
Cartoons and caricatures by Bevis Hillier
Dada by Kenneth Coutts-Smith
De Stijl by Paul Overy
An Introduction to Optical Art by Cyril Barrett
Modern graphics by Keith Murgatroyd
Modern prints by Pat Gilmour
Pop art: object and image by Christopher Finch
The Pre-Raphaelites by John Nicoll
Surrealism by Roger Cardinal and Robert Stuart Short
Symbolists and Decadents by John Milner
1000 years of drawing by Anthony Bertram

Arms and armour by Howard L. Blackmore
The art of the garden by Miles Hadfield
Art in silver and gold by Gerald Taylor
Costume in pictures by Phillis Cunnington
Firearms by Howard L. Blackmore
Jewelry by Graham Hughes
Modern ballet by John Percival
Modern ceramics by Geoffrey Beard